# Michelangelo Buonarroti

# Michelangelo Buonarroti

Life and Work

Alexandra Grömling

**KÖNEMANN**

**1475**          **1490**          **1495**

**1520**          **1530**          **1535**

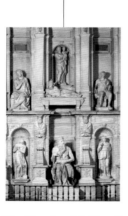

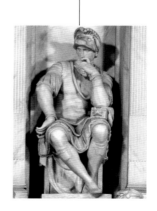

## Return to Florence
Page 24

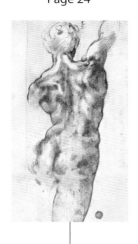

## The Sistine Chapel
Page 38

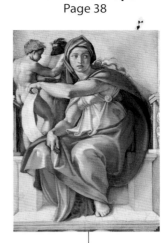

**1500** **1505** **1510**

**1540** **1550** **1564**

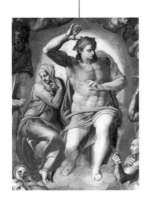

## Rome
Page 70

## The Later Works
Page 78

# Early Years

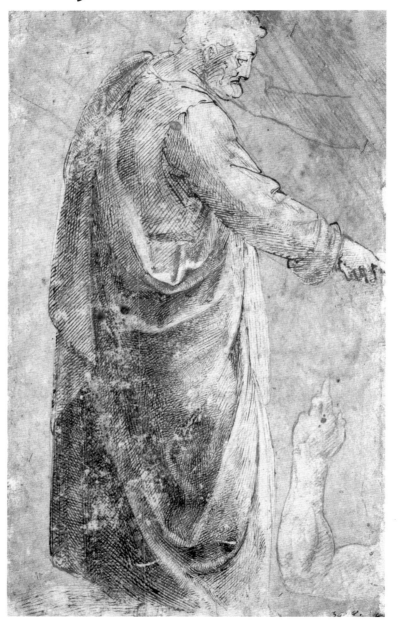

Michelangelo's artistic development took place in Florence, the "cradle of the Renaissance," a city that possessed an extraordinary wealth of architecture, sculpture, and painting. Here the young Michelangelo Buonarroti was able to study at first-hand the works of the major figures of the early Renaissance, in particular the frescoes of Masaccio and Giotto. And on his walks through the town he made drawings of its art and architecture – a valuable exercise for a young Florentine artist.

After leaving school early, Michelangelo, despite his father's opposition, began an apprenticeship in the workshop of the fresco painter Domenico Ghirlandaio. Just one year later, however, he left Ghirlandaio and turned his back on painting. Determined to be a sculptor, he studied in the gardens of the powerful Medici family, devoting himself to observations of the antique statues kept there. Lorenzo de' Medici soon learned of Michelangelo's talent and took him into his household "as a son," thus becoming Michelangelo's first patron.

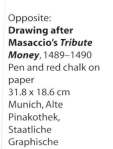

Opposite:
**Drawing after Masaccio's *Tribute Money***, 1489–1490
Pen and red chalk on paper
31.8 x 18.6 cm
Munich, Alte Pinakothek, Staatliche Graphische Sammlung

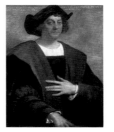

**Christopher Columbus**

**1474** Coronation of the Spanish Queen Isabella I.

**1479** Cyprus falls to the mercantile empire of the Venetians.

**1485** End of the Wars of the Roses in England.

**1487** The Portuguese sailor Bartolomeo Diaz rounds the southern cape of Africa.

**1492** Christopher Columbus discovers America.

**Three standing men, ca. 1492**

**1475** Michelangelo Buonarroti is born on March 6 in Caprese.

**1481** Michelangelo's mother dies.

**1485** Michelangelo's father marries again. The Buonarroti family moves to Florence and takes a house in the Via Bentacordi.

**1488** Michelangelo begins a three-year apprenticeship in the workshop of the painter Domenico Ghirlandaio. After just a year he leaves and begins to study the sculptures in the Medici gardens near San Marco.

**1490–1492** Michelangelo is a guest in the Medici palace.

# Youth

Whereas Michelangelo's 16th-century biographers, Giorgio Vasari and Ascanio Condivi, wrote poetically of Michelangelo as a "divinely inspired" genius born for the greater good of Florentine art, the Buonarroti family documents record the event more soberly, precisely noting the exact details of time and place. Michelangelo Buonarroti was born on March 6, 1475, in the small Tuscan village of Caprese near Arezzo. His father, Lodovico, a descendant of an old and once wealthy Florentine merchant family, was mayor of the town.

Just after his birth the family moved to their town house in Florence, and Michelangelo was handed over to a wet nurse in Settignano, a small town nearby whose main industry was the quarrying and working of marble. Because he had been entrusted to the wife of a stonemason, Michelangelo later liked to joke that he had taken in a love of sculpture with his nurse's milk. His childhood was to be divided between the small Buonarroti estate in Settignano and their house in Florence.

When Michelangelo was six years old, his mother died, leaving his father with six sons. As the extensive correspondence with his brothers shows, Michelangelo maintained a close relationship with his family until the end of his life, and supported them from the moment he began to earn money. He himself always lived very modestly.

**Michelangelo's birthplace in Caprese**

Below:
**Triton**, Settignano Villa Michelangelo Paris, private collection

This depiction of Triton, the sea god, was found on a wall in the Buonarroti house in Settignano and is thought to be Michelangelo's earliest surviving drawing.

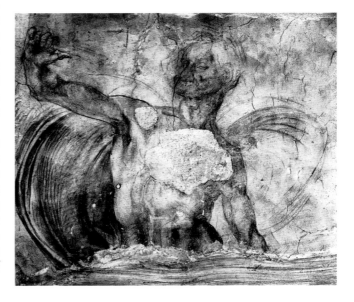

In Florence the family lived in the parish of Santa Croce, in the eastern part of the city. Michelangelo later bought a house there and today this "Casa Buonarroti" is a museum where important works by the artist are exhibited. The building, left to the city by the last surviving member of the Buonarroti family in 1858, also houses the Institute for Michelangelo Studies.

Florence's immense artistic wealth most certainly exerted a great fascination on the young Michelangelo. His biographers report that as a boy he showed little interest in his academic studies, preferring instead to spend his time drawing or in the company of artists.

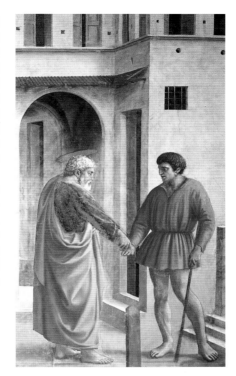

Masaccio
**Tribute Money,**
(detail), ca. 1425
Fresco
247 x 597 cm
Florence, Santa Maria del Carmine, Brancacci Chapel

Michelangelo made a copy of the figure of St. Peter here on the left (page 6) from this mural by Masaccio (1401–ca. 1428), one of the most important painters of the early Renaissance in Florence.

**View of Florence**, ca. 1490
Watercolor
Florence, Museo dell'Opera del Duomo

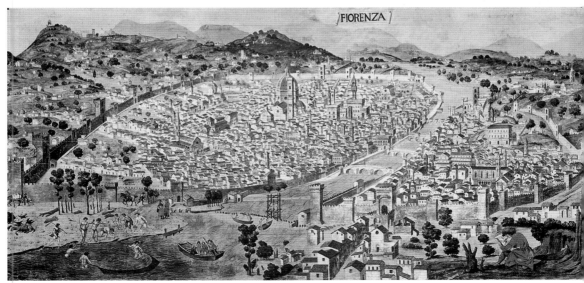

# Education

At first, Lodovico Buonarroti showed little understanding of his son's artistic ambitions. The family proudly thought of itself as belonging to the upper classes, and Lodovico considered the profession of artist inappropriate to their station in life. In the 15th century, painters and sculptors were still considered little more than craftsmen and, as such, belonged to guilds. Because there was no separate guild for artists, they were grouped together with apothecaries, physicians, and shopkeepers; sculptors belonged to the guild of goldsmiths. Not until the 16th century did the status and social position of artists change, a transformation in which the passionate commitment and astonishing creativity of Michelangelo played a major role. Soon it was no longer merely the technical skills of artists and sculptors that drew the admiration of patrons; increasingly they valued artists for their originality.

When he was 13, Michelangelo was apprenticed to the well-known Florentine fresco painter Domenico Ghirlandaio (1449–1494). The apprenticeship was meant to last three years, but he left after just 12 months. Contemporaries reported that Michelangelo's drawings were already beginning to outshine those of his master, and indeed the young artist's early drawings do show a precocious talent.

As Ghirlandaio was at that time working on a monumental mural

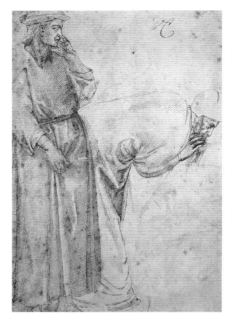

**Two Figures** after Giotto,
ca. 1490
Pen on paper
32 x 19.7 cm
Paris, Louvre, Cabinet des Dessins

Michelangelo copied these two figures from a fresco by Giotto in the church of Santa Croce in Florence (below) when he was about 15 years old. It was probably the impression of movement – subtly emphasized by the standing man's gaze directed at the bending figure in front of him – that interested the young Michelangelo.

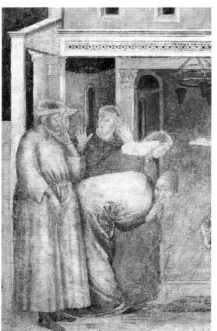

Giotto di Bondone
**Ascension of John the Baptist** (detail),
1313–1314
Fresco
Florence, Santa Croce, Perruzzi Chapel

In this group of astonished men observing John the Baptist's ascent to heaven, two figures caught Michelangelo's attention. He was able to study the differing body postures of the men standing in the foreground, the folds in their garments, and the relationship between their clothing and the bodies beneath.

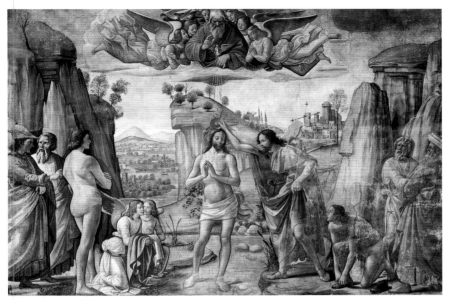

Domenico Ghirlandaio
**Baptism of Christ**,
1486–1490
Fresco
Florence, S. Maria Novella, Tornabuoni Chapel

Michelangelo probably worked with his master, Domenico Ghirlandaio, on the frescoes in the Tornabuoni Chapel, so gaining his first experience of mural painting techniques. The kneeling figure on the right is considered one of his earliest figures.

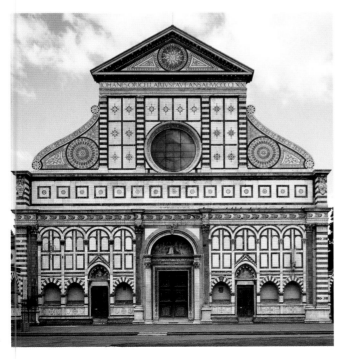

The façade of Santa Maria Novella
Florence, photo

cycle for the wealthy Tornabuoni family of Florence, Michelangelo was able to acquire the basics of fresco painting from him – skills that would prove essential later in his career. Large-scale compositions were especially suited to the techniques of fresco, in which pigment was painted on wet plaster.

The most important feature of an apprenticeship, however, was the development of drawing skills, and students devoted long hours to studying representations of space and the human body – the sciences of perspective and anatomy, innovations of the 15th century, continued to be the keen focus of artistic interest.

# The gardens of San Marco

The favor shown to Michelangelo by the Medici family was a rare mark of honor. The young Michelangelo not only gained access to the collection of antiquities belonging to the city's ruler, Lorenzo de' Medici, in his gardens near the monastery of San Marco, he also became a guest in the Medici household.

It is unlikely that there was any formal art school in the San Marco gardens. Instead, gifted young artists could study the sculptures of classical Greece and Rome. Michelangelo and his friend, Francesco Granacci, belonged to this select group from the time Michelangelo left Domenico Ghirlandaio's workshop. Bertoldo di Giovanni, a former assistant of the celebrated sculptor Donatello (1386–1466), had been appointed to oversee the gardens. He tutored the young artists in the technical aspects of sculpture, and at the same time introduced them to the outstanding artistic traditions of their own city. In the stimulating atmosphere of gardens full of ancient statues, these talented young artists were free to pursue their own studies.

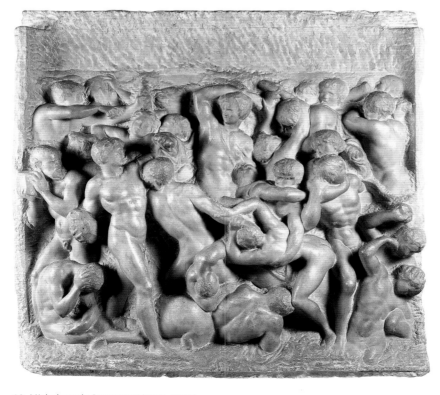

**Battle of the Centaurs**, ca. 1492
Marble
81 x 88.5 cm
Florence, Casa Buonarroti

The classical theme of the *Battle of the Centaurs* seems to have been inspired by the circle of scholars who frequented the Medici Palace. In this case, the impetus probably came from the tutor of the Medici children, Angelo Poliziano. Contemporaries particularly admired Michelangelo's ability to depict a large number of figures performing a range of different actions. Here men and centaurs – a mythical hybrid of horse and man – are seen locked in a fierce struggle. The graduated levels in which the figures are arranged lend the work an impression of depth. The relief remained unfinished after Lorenzo de' Medici's death in 1492, which is why the frame and some of the figurative details are almost completely unworked.

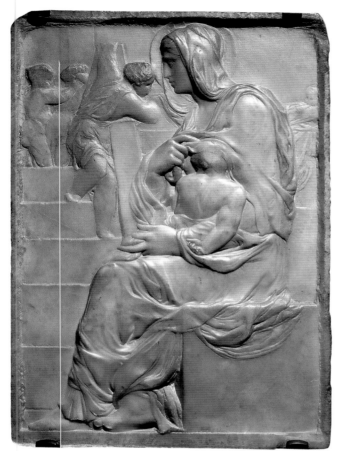

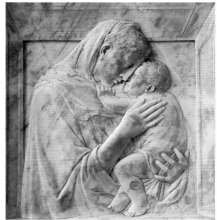

Donatello
**Madonna with Child (Pazzi Madonna),**
ca. 1417–1418
Marble
74.5 x 69.5 cm
Berlin, Staatliche Museen zu Berlin – Preussischer Kulturbesitz, Skulpturensammlung

Donatello's depictions of Christ's mother, Mary, influenced all the artists working in Florence, for both his treatment of figures and his use of perspective were innovative. Within the picture frame, the Madonna and Child are placed in front of an additional frame that looks like a window. This play on perspective (from the Latin *perspicere*, "to see through"), was a popular motif in the early Renaissance.

**Madonna of the Stairs (Madonna della Scala),**
ca. 1489–1492
Marble
55.5 cm x 40 cm
Florence, Casa Buonarroti

In his first marble work on a religious theme, Michelangelo depicted a subject popular at the time – the so-called *Madonna lactans*, the Virgin breast-feeding the Christ Child. The work is unusual in having Christ turn His back to the viewer; this astonishingly muscular baby seems to have fallen asleep at its mother's breast. Contrary to tradition, Mary looks off into the distance. The relief has been worked very close to the surface in a technique developed by Donatello called *rilievo schicciato*. The appearance of depth is provided by the finely graduated projection of the figures from the surface; this can be seen, for example, in the cherubs playing on the stairs.

Michelangelo's intellectual development was encouraged by contact with the many important scholars who were part of the Medici court. His first sculptural works – the *Madonna of the Stairs* (top left) and the *Battle of the Centaurs* (opposite) – were the products of this unique intellectual and artistic environment.

# Florence, the Medici, and Humanism

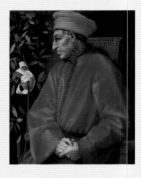

*Florence is home to the greatest minds. Whatever they turn their hand to, they effortlessly overshadow all other people irrespective of their fields of endeavor: as soldiers, politicians, scholars, philosophers or merchants.*

Leonardo Bruni (1379–1444)

Florence in the 15th century was one of the most important cultural and commercial centers in Europe. The wealth of its ruling Medici family was based above all on banking and commerce. Cosimo de' Medici (1389–1464), who was later called *Il Vecchio* (the Elder), was the sole heir to an enormous fortune, and by greatly expanding his father's banking business, he became one of the richest men of his age.

Although the city state of Florence was nominally a republic, power in fact lay in the hands of just a few influential families, notably the Medici. The Medici were the real rulers of the city for several generations, able to place trusted people in key public offices and so ensure the continuation of their family's rule.

But a class of cultivated art patrons was also required if the aura of power was to be maintained. Cosimo the Elder, who had learned Greek, encouraged the study of ancient texts and founded extensive libraries. In doing so, he made a decisive contribution to the cultural and intellectual movement known as humanism.

As an intellectual attitude characterized by its following of the cultural ideals and way of life found in antiquity, humanism had long been established in Florence. Since the mid-14th century, classical authors had been held up as literary models and the study of Latin and Greek pursued

Jacopo Pontormo
**Cosimo de' Medici**, 1518
Oil on wood
86 x 65 cm
Florence, Uffizi

diligently. It was believed that classical culture was superior to contemporary culture, and that its perfection could be matched only through imitation.

Florence's cultural highpoint was reached during the rule of Lorenzo de' Medici (1449–1492), the grandson of Cosimo. Lorenzo took over the reins of power at the age of 20, after the premature death of his gout-ridden father. Although dominated by a series of political crises and the continual decline of the Medici banking house, his rule marked the culmination of the family's rise to power.

Like his forefathers, Lorenzo de' Medici had a reputation as a generous patron of the arts and sciences. Unlike them, however, he was rarely a major client himself. Instead,

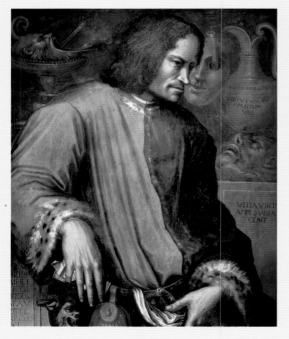

Giorgio Vasari
**Lorenzo de' Medici, the Magnificent**
1533
Oil on canvas
86.6 x 70.5 cm
Florence, Uffizi

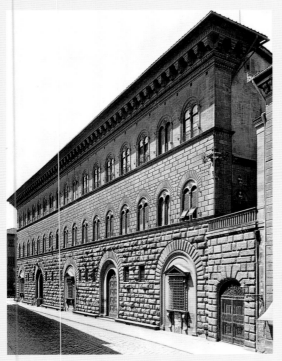

scholar of Latin and Greek, whom Cosimo had commissioned to translate the works of the Greek philosopher Plato – a huge undertaking that took him more than ten years to complete.

Ficino's pupil Giovanni Pico della Mirandola spoke Arabic and Hebrew as well as Greek and dedicated himself to the study of Oriental writings.

The linguist and literary scholar Cristoforo Landino popularized ancient Latin writers such as Virgil, Horace, and Pliny the Younger. He also composed a detailed commentary on the epic poem *The Divine Comedy* by Dante Alighieri, which was published in printed form for the first time in Florence in 1481.

The poet Angelo Poliziano taught Lorenzo's children,

and wrote many of his most famous poems in honor of the Medici.

The patronage of the Medici gave a huge impetus to the study of classical literature and art; without this impetus, the innovative compositions of Michelangelo's early work, such as *Battle of the Centaurs* and *Bacchus* (pages 12 and 21), would not have been possible.

his own activities as statesman, scholar, and poet created a cultural climate that allowed other members of the upper classes to become leading patrons. The result was a flowering of art, literature, and scholarship that even contemporaries referred to as the Golden Age.

Lorenzo's chief interests were poetry and humanist studies, and he frequently took part in the debates of a scholarly society established by his grandfather, Cosimo, to which some of the most important humanists in Italy belonged.

Lorenzo's tutor had been the philosopher and doctor Marsilio Ficino, a noted

Michelozzo di Bartolomeo
**Medici-Riccardi Palace in Florence**,
begun ca. 1444
Façade

Domenico Ghirlandaio
**Appearance of the Angel to St. Zachariah in the Temple** (detail showing the Humanists Marsilio Ficino, Cristoforo Landino, Angelo Poliziano, and Gentile de'Becchi), 1486–1490
Fresco
Florence, Santa Maria Novella

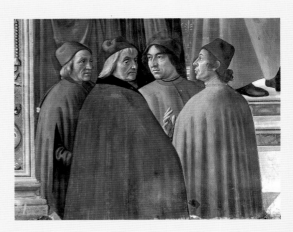

After Lorenzo de' Medici's death in 1492, his son Piero came to power. Piero, however, was not able to counter the increasing influence of the fanatical Dominican monk Girolamo Savonarola, nor to prevent an invasion by French troops under Charles VIII in 1494. He was finally driven from the city by an incensed populace.

As a favorite of the Medici, Michelangelo was also in danger. Shortly before the outbreak of unrest, the 19-year-old artist fled from his home town: Savonarola and his followers were coming to power and they were strongly opposed to any ostentation, particularly in the arts.

Michelangelo went first to Bologna. He returned to Florence a year later, and then embarked on his first journey to Rome – the city in which he was to spend a large part of his life.

**The Execution of Savonarola, 1498**

**Profile of a Youth, ca. 1500**

**1494** Devastating pogroms against the Jews in Spain under the Grand Inquisitor Tomás de Torquemada.

**1498** Vasco de Gama lands on the west coast of India. Leonardo da Vinci completes *The Last Supper* in Milan.

**1500** Portugal takes possession of Brazil.

**1494** Michelangelo leaves Florence. His patrons, the Medici family, are driven out of the city a short time later.

**1494–1495** Michelangelo is in Bologna, where he completes the statues for the grave of St. Dominica.

**1495** Return to Florence. *John the Baptist* completed in marble for Lorenzo di Pierfrancesco de' Medici, and *Cupid Asleep*. Both now lost.

**1496** First journey to Rome. Work for Cardinal Riario and the banker Jacopo Galli. Completion of the early works *Bacchus* and *Pietà*.

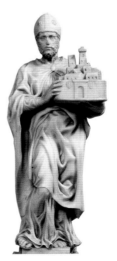

Opposite:
**St. Proculus** (detail),
ca. 1494–1495
Marble
Bologna, San Domenico

Right:
**St. Petronius**,
ca. 1494–1495
Marble
Height 64 cm
Bologna, San Domenico

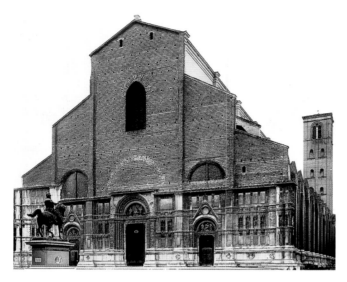

# Bologna

When Michelangelo first reached Bologna from the troubled city of Florence, he was poor but brimming with energy and ambition. He struck up a friendship with the aristocrat Gianfrancesco Aldovrandi, who took the young artist into his home for the next year. The two men were bound together not only by an interest in the arts but also by a love of literature, with Michelangelo introducing his Bolognese friend to the work of the three most famous Tuscan poets of the Renaissance: namely, Dante Alighieri, Giovanni Boccaccio, and Francesco Petrarch. The influence of this illustrious poetic triad can be seen in Michelangelo's own poetry; his first verses, written a few years later, were clearly influenced by Petrarch in particular.

**San Domenico**
Bologna, Photo

**Angel with Candlestick**, 1494–1495
Marble
Height 51.5 cm
Bologna, San Domenico

Although his heavy robe falls in thick folds, the body of this heavenly messenger can clearly be seen. This angel is more a muscular, winged youth than a delicate, supernatural creature. The motif of the kneeling angel was familiar to Michelangelo from the numerous depictions of the Annunciation.

Michelangelo received his first public commission from Aldovrandi, who was a member of the city council and therefore an influential man. His task was to carve the figurative decoration for the tomb of St. Dominic, the founder of the Dominican Order.

Work on this magnificent raised tomb had started as early as the 13th century, with carvings by the great Tuscan sculptor Nicola Pisano (active ca. 1258–84) and members of his workshop. According to Michelangelo's pupil and biographer Ascanio Condivi, Michelangelo himself carved the *Angel with Candlestick* (below) and the statuette of *St. Petronius* (page 17). Michelangelo also presented a simple model of the town to the archbishop and the city leader; it featured small block-like houses as

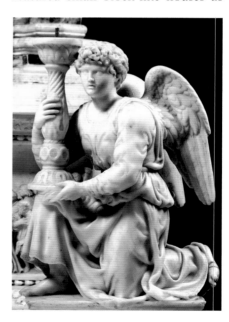

well as a pair of tall towers typical of the city, which were built by influential families.

One early source attributes another figure to Michelangelo, that of St. Proculus (left). Certainly the fiercely furrowed brow and S-shaped curve of the body seem to express an inner energy and unrest that supports the attribution. However, when seen in terms of the powerful artistic temperament Michelangelo expressed in his later monumental works, the tomb figures in the church of San Domenico seem small and insignificant. However, certain stylistic features typical of the later Michelangelo can already be detected here, such as the powerful, anatomically precise bodies, and the heavy garments richly draped and decorated.

**St. Proculus**,
ca. 1494–1495
Marble
Height 58.5 cm
Bologna, San Domenico

It is generally believed that this statue of St. Proculus, a Roman soldier in Bologna who was martyred by beheading, originally held a lance in his right hand. His dynamic and determined appearance contrasts with the appearance of St. Petronius, another patron of the city, whom Michelangelo

portrayed as a pensive older man (page 17).

The fractures in the stone – which can clearly be seen in the knees, arms, head, and in the cloak of the youthful saint – are the result of an accident which occurred in 1572. The statuette broke while being cleaned and had to be pieced together from the fragments.

# His First Visit to Rome

We can only speculate on the reasons for Michelangelo's journey to Rome. Was it a potential commission or the antique art treasures that lured him to the city? The work with which Michelangelo made his Roman debut, however, was a "fake." While still in Florence he had carved *Cupid Asleep*, which has since been lost. A shrewd dealer sold this work in Rome as an antique treasure at a price far above what he had paid Michelangelo. When the buyer – the connoisseur and collector of antiques Cardinal Raffaele Riario – noticed the deception, he demanded and received his money back.

This anecdote is an indication of the great value that the contemporary Roman art world placed on classical culture. A sizeable market for antique works had developed in the Eternal City, with some customers even going so far as to commission new works *all'antica* – "in the classical style." In their powerful physical presence, as well as their anatomical accuracy, Michelangelo's figures, carved or painted, clearly show the influence of the classical age. Rome, a city full of antique treasures, offered artists unparalleled opportunities for studying classical models.

Michelangelo did not find the Eternal City to be all splendor and magnificence, however. The Great Schism of the 14th century had weakened the Church, and by the end of the 15th century Rome was a run-down city. The ruins of ancient Rome lay in the middle of vineyards and fields surrounded by small medieval churches; the Forum was used as a marketplace for pigs; taverns and small shops had been erected in the Coliseum and Theater of Marcellus ... and thieves lay in wait in the Baths.

With his first two Roman works, a drunken Bacchus (opposite) and a moving Pietà (page 23), Michelangelo paid full tribute to Rome's dual heritage – its pagan past as well as its Christian present.

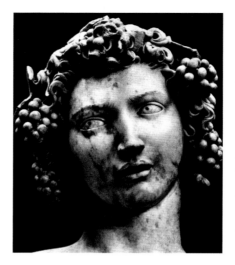

**Bacchus** (detail), 1496–1497
Florence, Museo Nazionale del Bargello

This statue of the god of wine, Bacchus, clearly shows the influence of antique sculpture on Michelangelo's work. The life-size naked figure stands in the *contrapposto* stance typical of classical art (opposite). Michelangelo may well have been asked by his client – probably the collector of classical works Cardinal Raffaele Riario – to produce the work "in the classical style."

The curves of the youthful Bacchus may suggest certain feminine characteristics: the god had been described by classical authors as possessing dual sexual traits. The drunkenness of Bacchus has been convincingly depicted; staggering uncertainly, his torso slightly twisted, he seeks support while staring with a bemused look at the cup in his right hand.

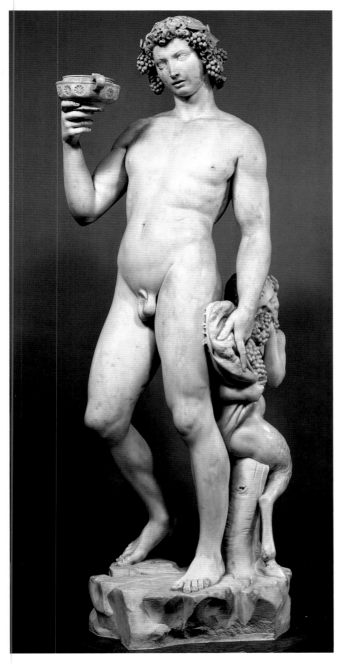

**Bacchus**, ca. 1496–1497
Marble
Florence, Museo Nazionale del Bargello
Below: detail

The sculptural group has been worked entirely in the round, so it shows the same high degree of finish on all sides. The viewer is invited to walk around the work and to consider it from all angles.

The small satyr, a creature from Greek mythology with goat's legs, tail, and horns, is a member of the god's entourage. In this sculpture the satyr also has a structural function, providing a support for the towering central figure.

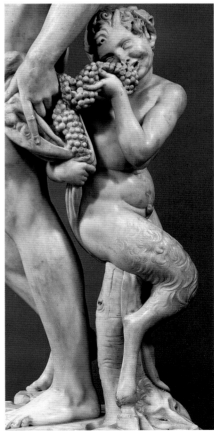

# The *Pietà*

*No corpse could be more corpse-like than this figure. And yet all its limbs are of a strange beauty. The face has an expression of unfathomable tenderness. The veins under the skin are so wonderfully worked that one is endlessly amazed that the hand of an artist could create such divine beauty.*

Giorgio Vasari (1511–1574)

### "The most beautiful marble statue in Rome"

The French Cardinal Jean Bilhères de Lagraulas commissioned this Pietà in 1498, probably for his funerary chapel in St. Peter's. Jacopo Galli, Michelangelo's patron in Rome, had secured the contract and assured the cardinal that the Pietà would be the most beautiful marble statue in Rome.

The sculptural motif of Mary and the adult Jesus was common in Europe north of the Alps, but rare in Italy. Perhaps this is why the contract expressly stated what the work should look like. It was to depict "the Virgin Mary draped in a robe with the dead Christ in her arms."

The Madonna's youthfulness is unusual: most portrayals showed the Mother of God as an older woman. Michelangelo is said to have remarked that Mary had retained her young appearance because of her virginity and purity.

### Form, composition, and figure

The Pietà depicts the moment when Christ, having been taken down from the Cross, lies in His mother's lap. The Madonna's right hand supports her Son's upper body while her left hand presents the body to the spectator, thereby inviting worship. She lowers her gaze and thus avoids direct communication with the viewer.

One of the most difficult challenges of this figurative group – how to combine in a single ensemble the seated and upright Madonna with the horizontal Christ – was solved brilliantly by Michelangelo: the body of Christ is almost entirely framed within the outline of the Virgin's body. This not only creates an exceptionally elegant composition, but also emphasizes the strong attachment of mother and son. The effect achieved by the statue derives largely from contrasts. For example, one of Mary's hands holds Christ's body but her other hand is open (presenting the body to the viewer); the elegant, nearly naked body of Christ lies amid the heavy folds of the Madonna's cloak; and while the Virgin's firmly based figure indicates a strong bond with the earth, Christ touches the ground only lightly with the point of his right foot.

The great significance this piece had for Michelangelo himself is indicated by the fact that it is his only signed work: he carved his name on the girdle that secures Mary's cloak.

Today the sculpture occupies an important position in St. Peter's in Rome, where it is housed behind protective glass.

Sandro Botticelli
**Lamentation of Christ**, ca. 1490
Wood
140 x 207 cm
Munich, Alte Pinakothek

Right:
**Pietà** (detail)

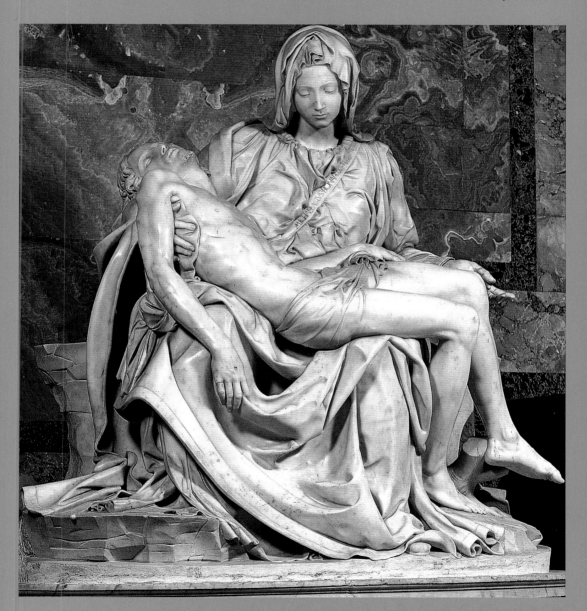

# Return to Florence 1501–1505

On his return from Rome, Michelangelo found the political climate in his hometown greatly changed in the absence of the Medici. A new, more democratic government on the Venetian model had been established in Florence in 1494. A Great Council with over 3,000 members now passed laws and made decisions on the awarding of civic positions.

After a period of serious political disturbance and change, the city's artistic life flourished once again. Michelangelo received important public commissions, the most famous of which was for his monumental *David*. Along with the great Leonardo da Vinci, he also received a contract to paint a mural in the city's council chamber. It was a period of intense creativity for Michelangelo, with wealthy and cultured Florentines now commissioning work from this remarkable young artist, whose reputation was growing day by day.

**Leonardo da Vinci, Mona Lisa, 1503**

**Portrait of a youth, 1501**

**1501** France and Spain conquer the Kingdom of Naples.

**1502** Wittenberg University, cradle of the Reformation, is founded.

**1503** Leonardo da Vinci paints the *Mona Lisa*.

Slavery begins under the Spanish in America. Death of Isabella of Castile.

**1504** Establishment of the first postal service by Franz von Taxis (in the Holy Roman Empire).

**1501** Michelangelo returns to Florence early in the year. He signs a contract for 15 statues for the Piccolomini Altar in the Siena Cathedral but, together with assistants, begins only a few pieces. Commission for *David* from the Guild of Wool Weavers.

**1502** Commission for a bronze *David* for French Marshall Pierre de Rohan. The work has since been lost.

**1503** Commission from the Guild of Woolen Weavers for statues of the 12 apostles for the Florence Cathedral. Only *Matthew* is begun.

**1504** *David* is erected in front of the Palazzo Vecchio in Florence. Commission for the mural the *Battle of Cascina* in the Great Council Chamber of Florence.

Opposite:
**Nude**, ca. 1504
Pen and pencil on paper
40.8 x 28.4 cm
Florence, Casa Buonarroti

Right:
**Virgin and Child with St. Anne**,
ca. 1501
Pen on paper
25.4 x 16.8 cm
Oxford, Ashmolean Museum

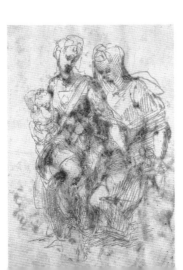

# The Madonnas

Among the private commissions the young Michelangelo received were two for circular reliefs depicting the Virgin Mary. Circular pictures (*tondi*) on the theme of the Madonna and Child with an infant John the Baptist were popular in Florence from the middle of the 15th century. They were often used by wealthy Florentine citizens for decorating the reception rooms of their palaces. But only a few of these works, which were intended for private devotions, were executed as marble reliefs.

Michelangelo proved himself particularly adept at the circular format: the seated figures fill the pictorial space without seeming confined, their slightly bent poses allowing them to fit the circle neatly. The Florentine artist Sandro Botticelli (1445–1510) also created magnificent *tondi* on the same theme, but in these he depicted only half-figures (below).

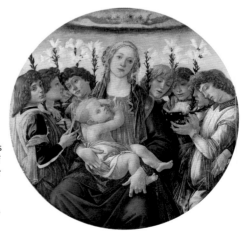

**Madonna and Child with the Infant St. John (Pitti Tondo)**,
ca. 1503
Marble
85.5 x 85 cm
Florence, Museo Nazionale del Bargello

Mary is seated on a low stone block, gently placing her arm around the standing Christ Child; her thoughtful gaze is directed into the distance as if she were contemplating the future suffering of her son. The Christ Child rests his elbow on the open book in his mother's lap and smiles gently. Mary dominates the composition; her posture is upright and her head is worked almost completely in the round, extending beyond the edge of the marble slab. This pose was later used by Michelangelo for the figure of the Oracle at Delphi in the Sistine Chapel (page 38).

Sandro Botticelli
**Madonna and Child with Angels**, ca. 1478
Tempera on wood
Diameter 135 cm
Berlin, Staatliche Museen zu Berlin – Preussischer Kulturbesitz, Gemäldegalerie

Eight angels stand tightly grouped in a semi-circle around Mary and Child, chanting hymns. In their hands these heavenly messengers hold lilies, symbols of Mary's purity. Circular pictures of this type were generally used for private devotions.

Michelangelo, by contrast, effortlessly placed entire figures within the round frame, the Madonna being either at one side or in the center. One of his particular skills is visible in the *Pitti Tondo* (opposite). The group is "rounded off" not only through the spatial relationship of both infants with Mary – the artist has also carved the folds of Mary's robe at her hip and feet so that the curve they form skillfully traces the shape of the frame.

In the *Taddei Tondo* Michelangelo concentrated on the interplay between the three figures (right). John the Baptist, the Virgin, and the Christ Child are bound together not only by their positions and gestures, but by the looks that they exchange as well. John the Baptist, identifiable by the baptismal bowl tied to his waist, looks at the Christ Child, who seeks refuge in his mother's arms, while Mary, in turn, looks at John the Baptist.

Work on both these *tondi* was abandoned even before Michelangelo's return to Rome, probably because of the sheer number of commissions he had received. In this incomplete state, however, they provide a fascinating insight into Michelangelo's way of working.

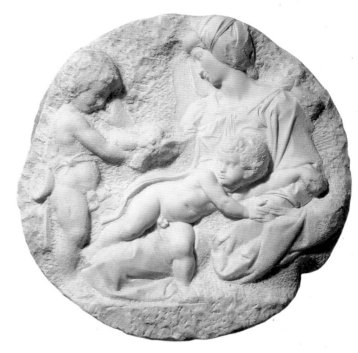

**Madonna and Child with the Infant St. John (Taddei Tondo)**,
ca. 1502
Marble,
Diameter 109 cm
London, Royal Academy of Arts

This relief makes a lively contrast with the *Pitti Tondo* (opposite) by showing the three figures bound together in a common activity. The Christ Child, fearing the beating wings of the bird held out to Him by the Infant John the Baptist, flees into the arms of His mother, who is seated on the ground. The Madonna calms St. John by stroking him gently on the cheek. The composition is most unusual in showing the young Jesus, future redeemer of the world, as fearful and fleeing. The motif of the bird was known from the 14th century, and is usually interpreted as a goldfinch, a symbol of the Passion of Christ. This unfinished relief shows various levels of working. The Christ Child and Madonna have been thoroughly worked, while John the Baptist has merely been roughly chiseled and, as in the *Pitti Tondo*, schematically drawn. This voy clearly reveals Michelangelo's method of developing his compositions around the figures. In this state, spatial relationships have not been defined and the composition has not been framed.

# The Holy Family: *Tondo Doni*

The only known panel painting by Michelangelo is dedicated to the theme of the Holy Family. It was commissioned by Agnolo Doni, a prosperous Florentine weaver who was an important patron in Florence at the beginning of the 16th century. Among the works he commissioned were portraits of himself and his wife by Raphael (1483–1520). He also collected antique art and gemstones.

The circular picture was probably ordered by Doni on the occasion of his marriage to Maddalena Strozzi, whose family coat of arms decorates the sumptuously carved and still original frame. Pictured in the frame's five medallions are the heads of two prophets and two sibyls as well as the head of Christ.

In the picture itself a bearded Joseph is seated behind Mary, who is shown as an astonishingly robust woman; unusually, she has bare arms. Her powerful physique points to Michelangelo's later sibyls on the ceiling of the Sistine Chapel. The Virgin has laid her book in her lap and, looking behind her, reaches back to take the muscular Christ from Joseph.

The three figures form a pyramid, a compositional principle that was introduced to painting by Leonardo da Vinci.

The figures are so well rounded that they seem to have been hewn from a block of stone, clearly indicating that Michelangelo found it easier to think as a sculptor than as a painter: the firm outlines of the bodies and the strong modeling in light and shade make the figures seem almost three-dimensional.

Compared with the warm colors of Luca Signorelli's circular painting *Madonna dell'Umiltà* (left), regarded as a model for Michelangelo's own composition, the dominant colors of the *Doni Tondo* are cool and metallic, and are therefore at odds with the tastes of the age. While the small half-figure of John the Baptist, in his animal-skin cloak standing to the right and rear of Mary, is a standard feature of Italian pictures of the same theme, the naked men in the background are more puzzling. They cannot – as in

**Study for the *Tondo Doni*,** 1503–1504?
Red chalk
19.9 x 17.2 cm
Florence, Casa Buonarroti

Signorelli's painting – be identified as shepherds. They possibly provide a contrast between the pagan world of the past and the Christian world represented by the Holy Family – a world from which they, and John the Baptist, are separated by a wall.

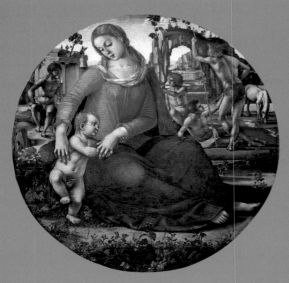

Luca Signorelli
**Madonna and Child (Madonna dell'Umiltà)**,
ca. 1490
Oil on wood
170 x 117.5 cm
Florence, Uffizi

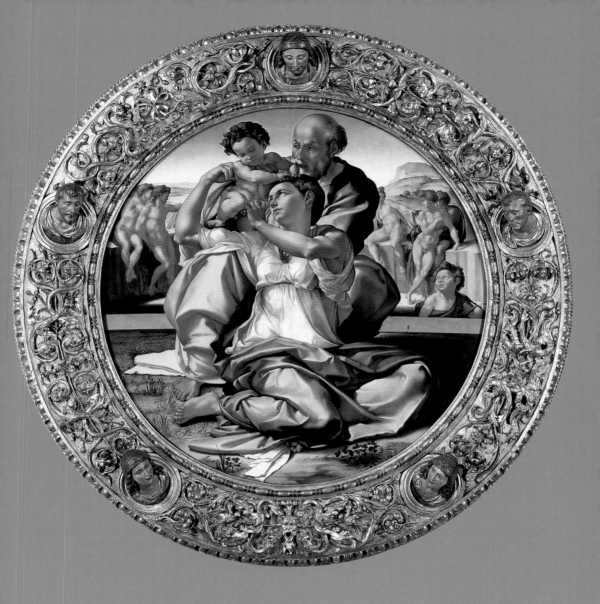

*Sculpture is the light for painting.*

Michelangelo Buonarroti

**Holy Family with John the Baptist (Tondo Doni)**,
ca. 1504–1506
Tempera on wood
Diameter 120 cm
Florence, Uffizi

The Holy Family: *Tondo Doni* **29**

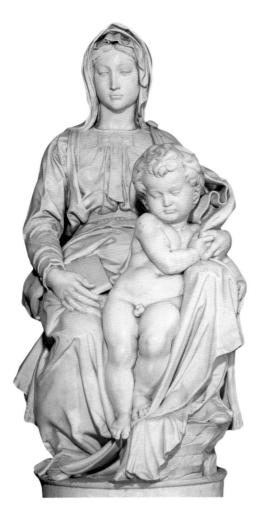

# Other Commissions

Two of Michelangelo's works surviving from this period are, in the contrasts they provide, superb examples of the range of his sculptural work and also of his artistry. They are the so-called *Bruges Madonna* – the only work by Michelangelo, apart from his two *Slaves* now in Paris, to have left Italy in his lifetime – and the unfinished *St. Matthew*, which was originally intended for Florence Cathedral.

Stylistically, the *Bruges Madonna* belongs to the start of Michelangelo's creative period in Florence in the years 1501–1505. In Mary's calm and beautiful countenance, in the statue's rich folds of the drapery and its almost perfect level of finish, it is very like the Pietà in St. Peter's (pages 22–23), which he had completed a little earlier. The Madonna was purchased by the Mouscheron family and placed on the altar of their family chapel in the church of Notre-Dame in Bruges.

It is not known whether this family of wealthy Flemish cloth merchants commissioned the work or bought it ready-made from Michelangelo. We do know, however, that his *St. Matthew* was commissioned by the Guild of Wool Weavers in Florence and was intended, together with 11 other uncompleted figures, to adorn Florence Cathedral.

As so often with Michelangelo's works, these sculptures are astonishing for the inventiveness of their composition. The Madonna does not

**Study for the *Bruges Madonna***
Pen on paper
London, British Museum

In this hastily drawn sketch Michelangelo has captured just the essentials of the two figures. The Madonna, however, is unclothed. Her muscular upper body may be an indication that Michelangelo made the sketch from a male model – a not unusual practice at the time.

**Bruges Madonna**,
1498–1501
Marble
Height 94 cm
Bruges, Notre-Dame

Here Michelangelo shows the affectionate relationship between mother and child being gradually transformed at the infant's initiative. The Christ Child begins to take a first cautious step away from the safety of his mother's lap, as if he were advancing towards his future suffering. The lowered gaze of the Madonna shows that she senses her son's terrible fate.

hold the Christ Child on her lap, as required by tradition. Instead, the infant has slid down between her knees and is about to take a few exploratory steps away from the protection of his mother.

While the *Bruges Madonna* is fascinating for its technical perfection, for the careful folds of the drapery, the finely modeled facial features, and the highly polished marble, the statue of *St. Matthew* captivates through very different qualities. Here it is the very incompleteness of the figure, its lack of finish, that awakens our imagination. The body's movements, suggested but not clearly defined, require us to complete the image imaginatively. In contrast to the tranquil, meditative Madonna, who already seems to know that her son is to be sacrificed, Matthew is characterized by the powerful tension of his strong body, which seems to be struggling unsuccessfully to liberate itself from the stone.

**St. Matthew**,
ca. 1503–1505
Marble
Height 271 cm
Florence, Galleria
dell'Accademia

It was probably because of his many commissions that Michelangelo was unable to finish this sculpture. In stark contrast to the *Bruges Madonna* (opposite), this statue still has a rough, coarsely worked surface. A book held by the Apostle in his left hand can just be made out, while his right hand can be seen reaching downwards. An enormous tension is conveyed by the violent, almost convulsive twist of his body.

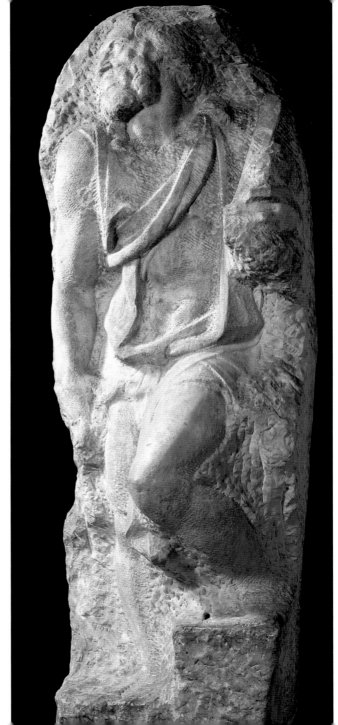

# The Renaissance

*In Tuscany, and especially in Florence itself, pictorial art has been born again.*

Giorgio Vasari (1511–1574)

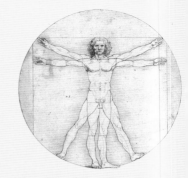

The French term *renaissance* was popularized by the Swiss cultural historian Jacob Burckhardt in *The Culture of the Renaissance in Italy*, first published in 1860 and now considered a classic. As early as the 16th century, the biographer and art critic Giorgio Vasari had spoken of the *rinascità* (rebirth), meaning that epoch which had begun in the late 13th century with Giotto di Bondone (1266 [?] –1337) and had reached its zenith in his own time, with Michelangelo.

The Renaissance arose in Italy as a broad movement that encompassed many diverse fields of activity. The dominant thinking of the day, steeped as it was in humanist ideals, held that art, philosophy, science, and politics should all work in concert. The ideal person was therefore one who was well-rounded and had a broad education – the so-called *uomo universale* ("universal man"). The Renaissance was characterized by men such as Lorenzo de' Medici, a statesman who also wrote poetry; by the artist, scientist, and engineer Leonardo da Vinci; and popes like Julius II, who was not only a great patron of the arts but also a military leader.

Florence was the cradle of the Italian Renaissance; the study of classical culture had been enthusiastically pursued there from the mid-14th century, and this had laid the groundwork for the cultural flowering that was to occur in the next two centuries.

Classical culture provided the yardstick and the model in almost all areas of life. The arts of antiquity, which were seen as having attained perfection, were zealously

Leonardo da Vinci
**Vitruvian Man**, ca. 1492
Pen over metalpoint
34.4 x 24.5 cm
Venice, Galleria dell'Accademia

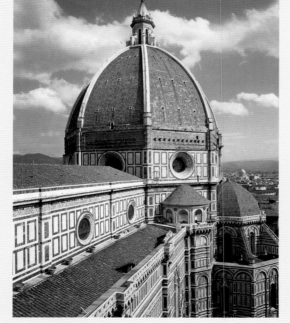

Left:
**Santa Maria del Fiore**, Florence Cathedral with dome by Filippo Brunelleschi
Photo

Opposite:
Raphael
**School of Athens**, 1510–1511
Fresco
Width 7.72 m
Rome, Vatican, Stanza della Signatura

imitated. As a result, secular themes from classical culture were increasingly taken up by Renaissance artists. Classical – and therefore pagan – philosophers and scholars were venerated even in the popes' private chambers, one of which was decorated with a fresco by Raphael which was entitled *The School of Athens* (below).

In the fine arts – painting, sculpture, and architecture – great value was placed on harmony and balanced proportions, especially in the depiction of the body. A new interest in mankind expressed itself not only in representation of the naked human form, but also in the emergence of the portrait in painting and sculpture. The middle classes of the Italian city republics were growing in self-confidence and soon became, along with the Church, the main patrons of artists, as the many individual and group portraits of the period clearly show.

The tendency to depict the human form realistically went hand in hand with close studies of perspective. One of the great discoveries of pictorial art was that of linear perspective, which enabled artists to create illusionistic representations of three-dimensional space on a two-dimensional medium such as paper, canvas, wooden panels, or sculptures in low relief. The Florentine architect and sculptor Filippo Brunelleschi (1377–1446) was regarded as the inventor of centralized perspective, and his contemporaries and later artists (such as Uccello) competed to outdo each other in the creation of complex perspectival compositions.

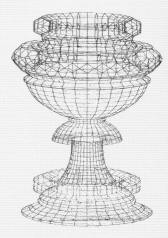

Paolo Uccello
**Perspective Drawing of a Chalice**,
ca. 1450
Pen on paper
34 x 24 cm
Florence, Uffizi

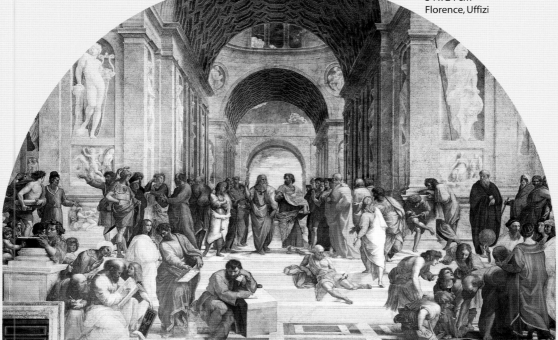

# Competing with Leonardo

In the autumn of 1503, the Republic of Florence decided to decorate the council chamber of the Palazzo Vecchio with depictions of the city's glorious victories. Early in 1504 Leonardo da Vinci (1452–1519), who by this stage enjoyed a very high reputation, was employed to paint a mural of a battle fought in 1434 between Florentine forces and a Milanese army at Anghiari, south of Florence. When, six months later, Michelangelo was commissioned to

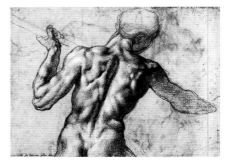

**Study for the *Battle of Cascina*,** ca. 1504
Charcoal, partially highlighted with white chalk
18.8 x 26.2 cm
Vienna, Graphische Sammlung Albertina

This preparatory sketch was probably done from a posed model. The figure appears again in the background of the *Battle of Cascina*.

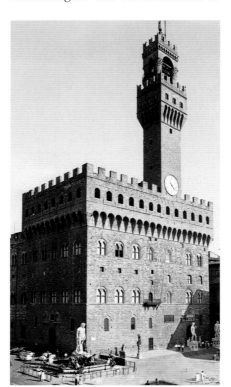

**Palazzo Vecchio**
Piazza della Signoria
Florence
1299–1382
Photo

The Palazzo Vecchio – known as the Palazzo della Signoria until well into the 16th century – was the seat of the city government, the Signoria. Built at the beginning of the 14th century, it underwent numerous alterations and additions. The solid walls and projecting crenellated battlements give it the appearance of a fortress. In front of the portal there now stands a copy of Michelangelo's *David*, while his *Victor* decorates one of the halls.

paint yet another Florentine victory, that of 1364 against Pisa, it meant that the two most famous artists of the day were engaged to work at the same place.

The result of this remarkable competition could have been unparalleled, but neither of the artists completed their commissions. However, their cartoons (full-size preparatory drawings) were exhibited at the time. These were much admired by fellow artists, and repeatedly studied and copied by succeeding generations. Our knowledge of the original compositions by Leonardo and Michelangelo are based on these copies by other artists, as well as the preparatory studies by the masters themselves; the original cartoons have not survived.

In contrast to Leonardo's choice, Michelangelo did not select a battle scene for his painting. Instead, he

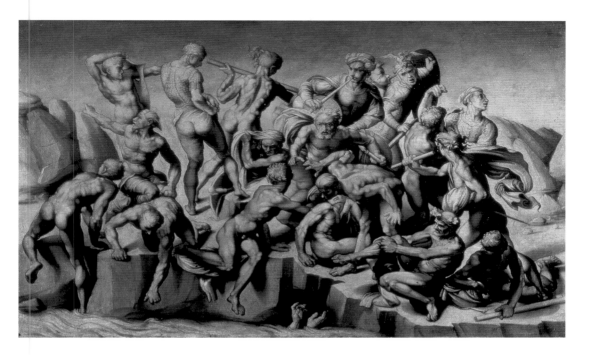

Aristotile (or Bastiano) della Sangallo
**Copy of Michelangelo's cartoon for the *Battle of Cascina*,**
ca. 1542
Grisaille on canvas
Holkham Hall
Earl of Leicester's Collection

"The classroom of the world" was how the Florentine sculptor Benvenuto Cellini (1500–1571) respectfully referred to Michelangelo's epoch-making composition. It has survived in this copy.

depicted an event that preceded the fighting: a scene showing a few soldiers who, bathing in the river Arno, are surprised by a sudden call to arms. This choice gave Michelangelo an opportunity to display his skill in portraying the naked body in a great range of poses. His expressive rendering of this dramatic situation greatly impressed his first biographer, Vasari, who particularly admired the depiction of an old man with a wreath of ivy on his head. In the midst of the din of battle and the clash of weapons, the man (seated on the right) contorts himself as he struggles to pull tight stockings over his wet legs.

Peter Paul Rubens
**Copy of Leonardo da Vinci's design for the *Battle of Anghiari*,**
ca. 1600
Oil on canvas
45.2 x 63.7 cm
Paris, Louvre, Cabinet des Dessins

Rubens did not make this copy of Leonardo's celebrated depiction of a cavalry charge from the original cartoon, but from a copperplate engraving from the year 1558.

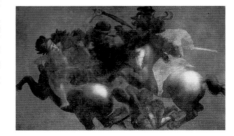

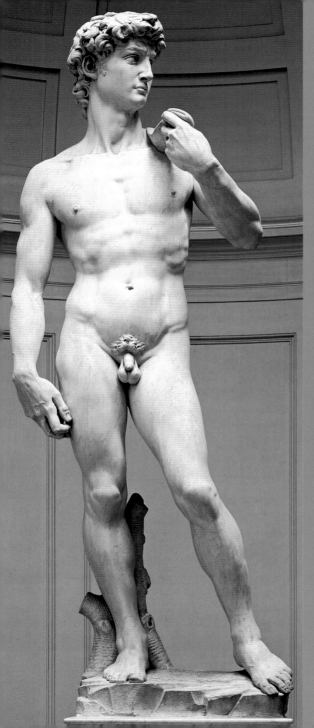

# *David*

The "Giant," as the over four meter colossus was called at the time of its erection in Florence, had to wait almost 40 years to be freed from its marble block. The sculptor Agostino di Duccio had received the commission to create a figure for an arched buttress of the Florentine Cathedral as early as 1463. As the object was to be clearly seen from below, this high location made it necessary for the work to be of gigantic proportions. The artist therefore chose an enormous block or marble from the quarries of Carrera which, proving too much for him artistically, he gave up after his first rough work on it. Antinio Rosselli also failed when he was called on to finish the figure in 1476. It was in 1501, with Michelangelo, that a master was finally found, capable of tackling the block. The statue he was to complete already had a name: David. Through his courage and intelligence, this Old Testament hero had emerged victorious in his fight with Goliath, and so saved his people from the Philistines. The handsome young shepherd had felled the bigger and stronger Goliath with a single stone from his sling, and had then cut off his head with a sword.

Michelangelo shows David as an athletic youth, completely naked, and with his sling resting casually on his shoulder. Quiet and concentrated, he appears to be gathering his strength for the coming fight. He turns his head to his left, directing his gaze self-confidently into the distance; only his furrowed brow reveals the intense concentration with which he regards his opponent.

For the Florentines, the unveiling of the statue must have been a shock. No free-standing monumental sculpture of this size had been completed since antiquity; moreover, this naked "giant" was far removed from all the other depictions of David previously known in Florence. In the 15th century this biblical hero had generally been portrayed as a warrior with a sword and helmet, or even in armor; at his feet there usually lay the head of Goliath like a trophy.

Michelangelo did away with David's traditional attributes, with the sword, the helmet, the decapitated head. Instead, he characterized David solely

**David**, 1501–1504
Marble
Height 410 cm
Florence, Galleria dell'Accademia

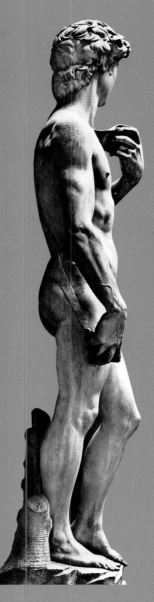

by his sling, over which he gazes intently to size up his opponent.

In contrast to traditional portrayals of David, Michelangelo's David is not to be understood as an image of victory, but as the embodiment of youthful strength and self-confidence.

Michelangelo worked on the piece for two and a half years in a temporary studio close to the cathedral. It has a main frontal aspect, whereas Michelangelo's other free-standing statues were worked "in the round" and so can be viewed from all sides. This was probably because the block of marble had already been partly worked by others, and as a result there were severe restrictions on what Michelangelo could do. However, these limits did not prevent Michelangelo from depicting his David contrapposto – in a pose in which the body's weight rests on one leg, the shoulders being at an angle to the hips, a posture that lends a figure animation.

The biblical David had assumed a symbolic character for the city of Florence. Apparently weak, and yet able to defeat a stronger enemy through his skill, courage, and intelligence, he was a figure with whom the small city state of Florence, often in conflict with its neighbors, could readily identify.

In January 1504, shortly before the statue was completed, a commission of 30 of Florence's most

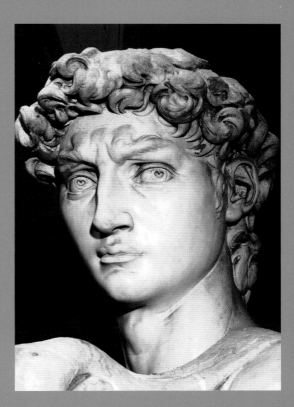

**David** (detail)
Head

important citizens was convened to discuss where Michelangelo's David should be placed. After a long discussion it was decided – probably in line with the artist's wishes — to erect David in front of the Palazzo Vecchio, the seat of the city's government.

For reasons of conservation, in 1873 the original was moved to a location underneath its own dome in the Florentine Galleria dell'Accademia. A marble copy has stood in front of the Palazzo Vecchio since 1910.

After Michelangelo had made a bronze statue of Pope Julius II (now lost) for the cathedral in Bologna, he was charged by Julius with a new project: vast frescoes for the ceiling of the Sistine Chapel. Though these frescoes would rank among his very finest and most admired achievements, Michelangelo was initially unwilling to accept the commission: he did not think of himself as a painter, and on the contract to which Pope Julius II bound him in 1508 he willfully signed himself "Michelangelo, sculptor."

Nevertheless, he threw himself into the vast project with unbelievable energy, and completed it essentially single-handedly. He even went as far as to extend the iconographic program drawn up by the pope, the 12 Apostles originally meant to decorate the ceiling being replaced by over 300 Old Testament figures.

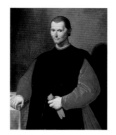
**Niccolò Machiavelli**

**Zachariah, a study for a figure in the Sistine Chapel.**

**1508** Raphael begins painting the Vatican chambers (including *The School of Athens*)

**1509** Henry VIII ascends to the English throne. Earthquake in Constantinople kills 13,000 people.

**1510** First pocket watch is made.

**1511** Pope Julius II concludes the "Holy Alliance" with Spain, Venice, England, and Switzerland against France. Spain takes possession of Cuba.

**1512** Return of the Medici to Florence. Niccolò Machiavelli is dismissed from the city council and begins to devote himself to his political writings.

**1508** After completing a bronze statue of Julius II (which has not survived) in Bologna, Michelangelo returns to Florence. In Rome he signs a contract with Pope Julius II for the ceiling frescoes of the Sistine Chapel.

**1510** The eastern half of the ceiling is probably completed during the summer. Because of financial difficulties, Michelangelo travels to Bologna, where the Pope is in residence.

**1511** After returning to Rome, he begins to paint the second half of the ceiling.

**1512** Michelangelo buys two houses in Florence. On October 31 the ceiling frescoes are unveiled in the Sistine Chapel.

Opposite:
**The Oracle at Delphi**,
1509
Fresco
Rome, Vatican,
Sistine Chapel

Right:
**Man Painting a Ceiling Fresco**
This quick sketch appears on the edge of a sheet on which Michelangelo wrote a sonnet, 1510
Florence, Casa Buonarroti

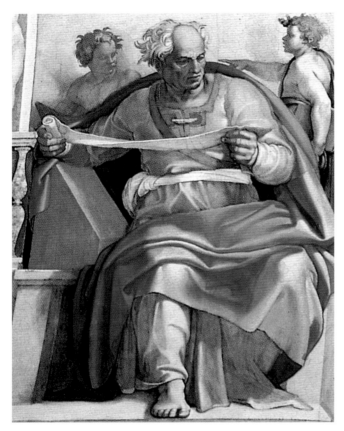

# An Unwilling Painter

"I am living here in a state of great anxiety and of the greatest physical fatigue; I have no friends of any sort and want none. I haven't even time enough to eat as I should." So wrote a tormented Michelangelo to his brother Buonarroto in 1509; he had begun work in the Sistine Chapel the year before. The vaulted ceiling of the

**The Prophet Joel**
(detail of the ceiling fresco on pages 42–43)
Rome, Vatican, Sistine Chapel

Joel was one of the seven prophets. Here, through his depiction of the prophet's powerful body, Michelangelo has been able to convey the inner intensity generated by reading the open scroll.

room he was to decorate, sometimes known as the Hall of the Cardinals, had an area of over 500 square meters (over 1,295 square feet) and was decorated with a star-filled heaven that Michelangelo had been ordered to replace with geometric patterns and depictions of the Apostles. But he found this scheme unsatisfactory – in his own words a "rather poor thing" – and proposed a new and significantly more detailed version that contained over 300 figures. Instead of the Apostles he now painted seven prophets and five sibyls who, along with numerous other figures, flank nine Old Testament stories. These visionaries – the prophets and the sibyls – are depicted enthroned on painted stone benches, poring over books and scrolls or committing their visions to parchment.

The sequence of the main panels starts on the altar side of the chapel with the Creation, but Michelangelo actually began his work on the opposite side, painting the events in counter-chronological order. A striking feature of the frescoes is the way in which the figures became progressively larger. The closer Michelangelo got to the altar the bigger, more powerful, and more dynamic his figures became. Finally, at the end of three and a half lonely years on scaffolding he had constructed himself, and after bitter wrangles with an impatient papal client, Michelangelo officially opened his work to the astonished gaze of the Roman clergy on October, 31 1512.

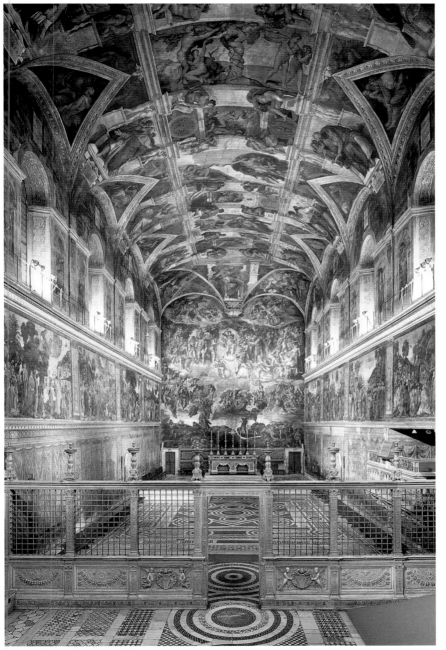

**Interior of the Sistine Chapel**
Photo

The Sistine Chapel was built on the orders of Pope Sixtus IV and named after him. This sacred chamber served as an assembly hall for the cardinals, especially when they met in conclave to elect a new pope and to celebrate High Mass. Between 1481–1483 Sixtus IV had the chapel decorated with frescoes, employing many of the most famous painters in Italy, including Botticelli, Perugino, Signorelli, Cosimo Rosselli, and Ghirlandaio, Michelangelo's first teacher. The side walls had cycles depicting Moses and Christ, while above them, between the windows, are images of prominent Popes. Michelangelo painted the ceiling frescoes for Pope Julius II; he later (1536–1541) completed *The Last Judgment* on the altar wall for Pope Paul III.

Following pages:
**Michelangelo's Sistine Chapel frescoes**
Rome, Vatican, Sistine Chapel

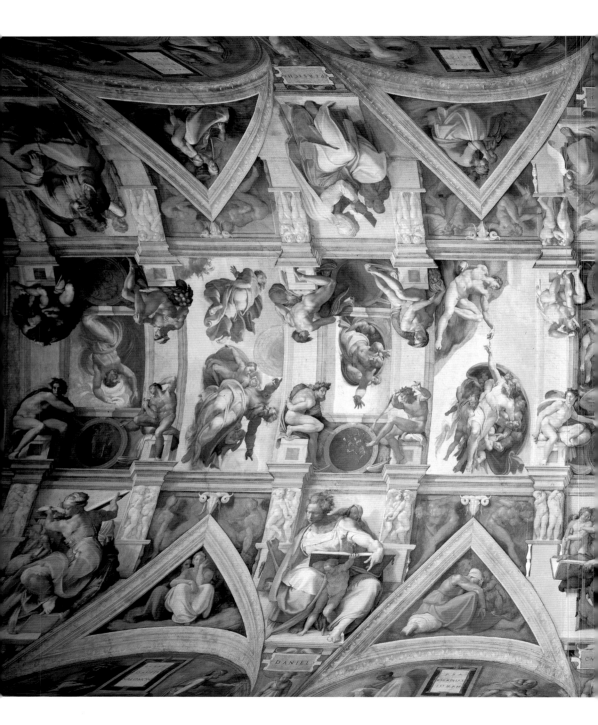

DANIEL

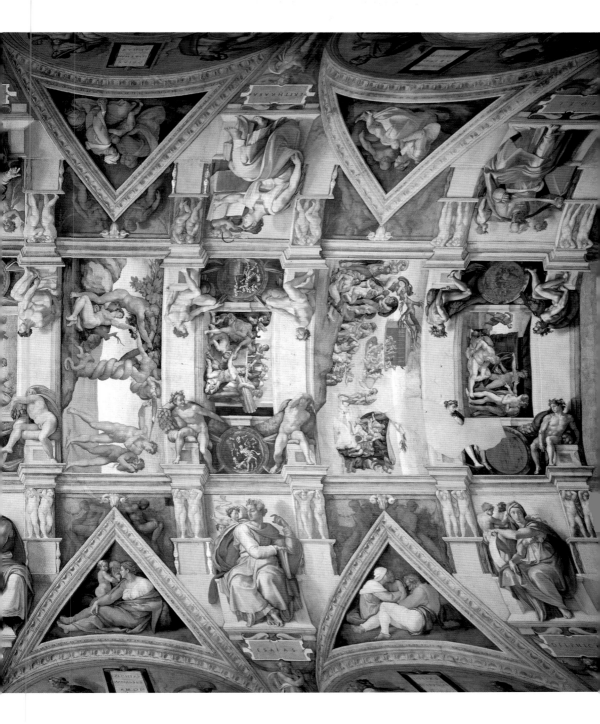

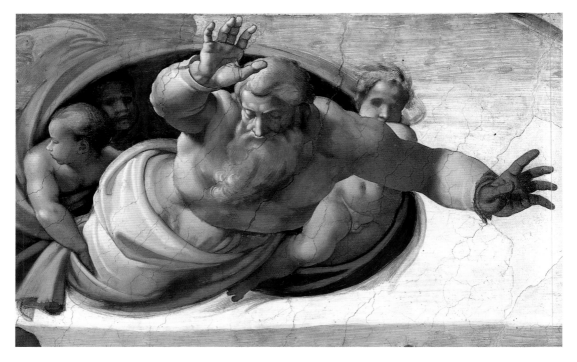

# Creation

Five of the nine images in the middle of the ceiling show scenes from the story of the Creation. They are *The Creation of Light and Darkness, The Creation of the Sun and Moon, The Separation of the Heavens from the Waters, The Creation of Adam*, and *The Creation of Eve*.

The biblical stories are depicted alternately in large and small panels. The smaller ones are framed at the side by pairs of naked youths, so-called *ignudi* (from Italian *nudo*, "naked"), some of whom are lightly draped. A few of them wear garlands of oak leaves and acorns (a symbol of the della Rovere family, to which Pope Julius II belonged); others have golden shields on which are portrayed other Old Testament scenes. These naked youths are pictured lounging in a variety of seated positions on the stone architecture, an approach that enabled Michelangelo to display his virtuoso treatment of the human form.

In the Creation scenes, painted in the last phase of Michelangelo's work on the ceiling of the Sistine Chapel, his brushwork became increasingly free and energetic. At the same time the compositions became more abstract as they harmonize more closely with the themes of the Creation.

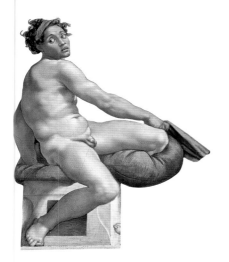

**Naked Youth (Ignudo)** Over the Erythrean Sibyl, 1509
Fresco
Rome, Vatican,
Sistine Chapel

Michelangelo himself named these pairs of naked youths *ignudi*. The word has since been taken up by art historians as a technical term for this type of depiction.

Michelangelo made dramatic use of an important artistic technique in these ceiling frescoes: foreshortened perspective. In *The Separation of the Heavens from the Waters*, an event that takes place on the second day of the Creation, he shows the body of God, surrounded by angels, dramatically foreshortened; with His outstretched, commanding arms and lowered head, God appears to be flying out of the sky directly towards us. The accompanying angels are hidden in His billowing, funnel-like robes. Michelangelo reinforces the painting's depth of perspective by means of another compositional trick – one of the angels turns back to look into the space traversed in their flight through the universe.

**The Creation of the Sun and the Moon**,
1511, Fresco
280 x 570 cm
Rome, Vatican,
Sistine Chapel

"And God made two great lights; the greater light to rule the day, and the lesser light to rule the night; he made the stars also" (Genesis 1, 16). Michelangelo depicted the creation of the Sun and Moon as an act of stupendous, violent movement. In contrast, he painted a second scene in which he daringly portrayed the Creator from behind (on the left of this illustration). Here God is in the act of creating the Earth's vegetation, which appears beneath Him and to the left.

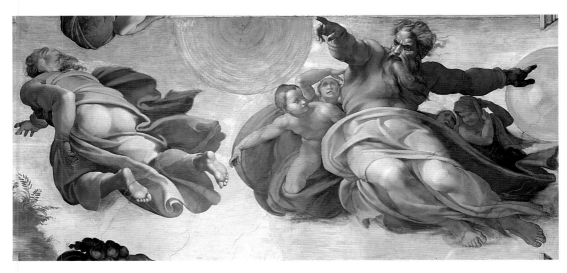

# The Creation of Adam

*In the entire world of art there can be no example of a more brilliant rendering of the supernatural in a completely lucid, articulate and sensual moment.*

Jacob Burckhardt (1818–1897)

Giorgio Vasari has provided us with an apt description of this most famous scene in the Sistine Chapel: "God the Father is borne up by a group of naked cherubs, who appear to be carrying the weight of the entire world rather than just one figure; it [the painting] gives this effect through the awesome majesty of God and His movement as He embraces some of the cherubs with His arm, almost as if He were allowing himself to be carried; but His right hand reaches out to Adam, who is pictured with such beauty, poise, and clarity of contour that one might almost believe he was made by his Creator and not by the drawings and brushstrokes of a fellow man." Vasari vividly describes the angels surrounding God. On the one hand, these heavenly creatures seem to be carrying His massive body through the air with all their might; but the angels in the upper part of the robe show just how lightly they are floating through the air at God's side. The Creator's heavy red cloak billows up to assume the shape of a shell that protects His "traveling companions" from the cosmic winds created by His headlong flight. The angels crowd around Him as though around a father, full of trust and affection. Curiously, Vasari does not mention the beautiful young woman who sits among the angels. God embraces her with His left arm while she looks inquisitively towards the awakening figure of Adam. This woman has been interpreted as Eve, who, at this point in the story, has not yet been created but exists in God's mind and has therefore already taken form. Adam, to whom Vasari ascribes supernatural beauty, is propping himself up in a bare, rocky landscape and gazing devotedly at his creator.

None of God's dynamism can be read in the figure of Adam; it is only with difficulty that he seems to hold up his hand, the relaxed fingers slightly spread. The entire figure of God, by contrast, down to the outstretched finger, is an

Above:
**Study for *The Creation of Adam***, ca. 1510
19.3 x 25.9 cm
Red chalk on paper
London, British Museum

Left:
Lorenzo Ghiberti
**Adam and Eve**
(detail from *The Gates of Paradise*), 1425–1452
Gilded bronze
80 x 80 cm
Florence, Baptistery

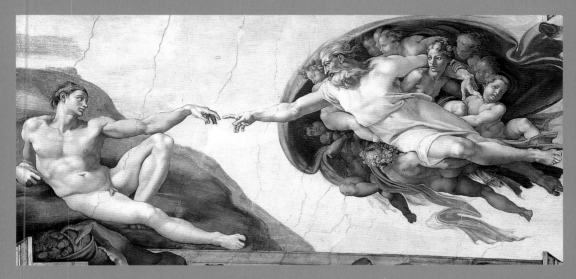

**The Creation of Adam**
1510
Fresco
280 x 570 cm
Rome, Vatican,
Sistine Chapel
Below: detail

image of the utmost concentration as He transfers His divine energy to Adam and so breathes life into him. God's gaze rests firmly and resolutely on His creation. Nevertheless, the effort required by this act is obvious, for His forehead is deeply lined. The care and sensitivity of Michelangelo's technique is evident in the small details of the face,

such as the lines around the eyes. Even God's gray wind-blown hair is painted with the finest brushstrokes, as if the fresco was meant to be seen close up.

Michelangelo almost certainly had the *Adam and Eve* relief in the portal of the Florentine Baptistery in mind when he composed his variation on this theme (opposite, bottom left). The ten panels of these gilded bronze doors, which were made from 1425 to 1452 by the Florentine sculptor Lorenzo Ghiberti (1378–1455), show scenes from the Old Testament. Because of their unearthly beauty, Michelangelo called the doors the "Gates of Paradise," a name by which they then became known. Michelangelo's version of the scene is not the same as Ghiberti's, however. In particular, Michelangelo's composition is revolutionary

in its portrayal of God. While his Adam is shown in a pose similar to that of Ghiberti's Adam (as in traditional representations), his depiction of God in a horizontal position was something altogether new; previously, God had been shown standing on the ground while blessing Adam. Another strikingly original feature was the outstretched finger with which God endowed His creation with life. This innovation, which vividly embodies the abstract concept of the Creation, has become the most famous depiction of the theme.

# Drama, Figures, and Space

The narrative drama of Michelangelo's vibrant and dynamic frescoes is brought out effectively in the four panels that are in the eastern part of the vault, towards the entrance. Seen from the altar, the panel featuring *The Temptation and the Expulsion from Eden* is followed by *The Sacrifice of Noah After the Deluge*, *The Deluge*, and finally *The Drunkenness of Noah*.

Other Old Testament stories done in a large format also decorate the four pendentives in the corners of the vault. The most spectacular of these is *The Execution of Haman* (opposite, bottom right). In this curved triangle, an extremely complicated picture surface, Michelangelo skillfully combined four different scenes from the Book of Esther, making optimum use of the available space. The dramatic high point is the terrible crucifixion of Haman. The distorted naked figure is foreshortened in perspective, and so convincingly positioned in the picture space that it seems about to burst through the very surface. The dynamic, outward thrust of the figure of Haman effectively counters the inward-curving surface of the pendentive. While the spatial structure is simple and spare, the poses of Haman and the king in his bedchamber, who are mirror images of each other, draw the viewer into the scene.

Once again, in *The Temptation and the Expulsion from Eden* (below) it is by means of his depiction of figures, this time in a stark landscape, that Michelangelo develops the drama of the events. Whereas Adam and Eve are portrayed in the first part of the picture in languid, relaxed poses as they reach for the apple, after the Expulsion their bodies are hunched over in fear, their faces lined and anguished. In the scene in the Garden of Eden, Adam and Eve are shown integrated into a specific pictorial space, while in the next scene, where they are being driven out of Eden by

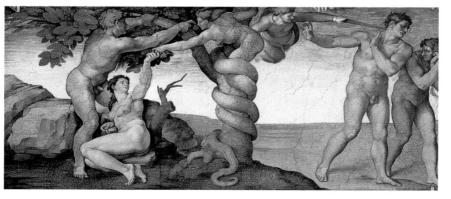

**The Temptation and the Expulsion from Eden**, 1509
Fresco
280 x 570 cm
Rome, Vatican, Sistine Chapel

The temptation of Adam and Eve by the Serpent and their expulsion from Paradise were painted in a unified pictorial space but as two individual scenes separated by the Tree of Knowledge. A sophisticated compositional device connects the two episodes: the outstretched arm of Adam at first reaches for the object of his desire, while on the right-hand side it is held up in a gesture of fear and defense.

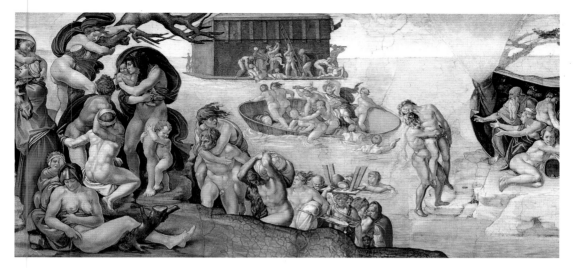

the Angel of the Lord, they seem to wander into an infinite and threatening space.

In *The Deluge* (above), a fresco with the same rectangular format, a multitude of figures had to be accommodated. Here Michelangelo used the pictorial space in quite a different way, populating the foreground, center, and background with people performing in a wide variety of actions.

In contrast to the other paintings shown here, the events in *The Deluge* do not follow each other in chronological order; instead, they take place simultaneously.

**The Deluge**, 1508–1509
Fresco
280 x 570 cm
Rome, Vatican, Sistine Chapel

Trying desperately to escape the rising water, terrified men, women, and children are making their way to rocky outcrops and high ground, and to an overcrowded boat – Noah's Ark (in the background) has room for only a few. In 1797 an explosion at the nearby Castel Sant'Angelo damaged this fresco, which is why the tree on the right of the picture – which, in contrast to that on the left, still bears leaves – is difficult to make out.

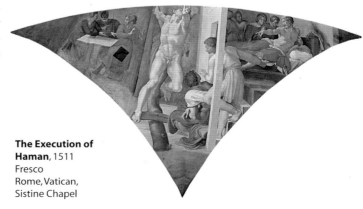

**The Execution of Haman**, 1511
Fresco
Rome, Vatican, Sistine Chapel

# Fresco Painting and Restoration

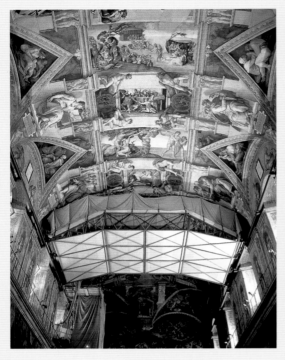

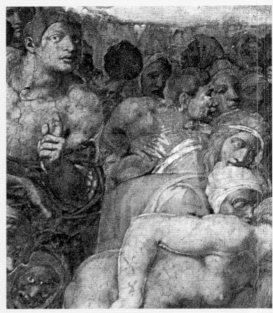

Left: **Scaffolding used for the restoration of the ceiling frescoes in the Sistine Chapel.**

Michelangelo learned the technique of fresco painting from his first master, Domenico Ghirlandaio, in Florence. As the major restoration carried out from 1990 to 1994 has shown, in the Sistine Chapel Michelangelo developed these techniques to what the chief conservator, Gianluigi Colalucci, called "the peak of perfection."

The term "fresco" is derived from the Italian word for "fresh," for the painter applies pigment to freshly laid plaster. Only while the plaster is still wet is it possible for the pigment to bond chemically with the plaster, and so create an image that is indelibly fixed to the wall.

In order to paint the fast-drying plaster while it is still fresh, the artist has to work quickly and very accurately. Moreover, only a certain amount can be plastered and painted in one day; these sections of daily work, called *giornate*, can be made out by closely examining the edges of the plaster and subtle changes of color. The large expanses of the *giornate* on the ceiling of the Sistine Chapel show with what astonishing speed Michelangelo worked.

Before a fresco was executed, however, certain preparations had to be made. The wall was first coated with different layers of plaster; in general the first layer was rough and a second, finer layer was suitable for painting. The artist then transferred an original design from a prepared cartoon on to the damp surface. This was done by first pricking small holes along the contours of the image and then standing the cartoon against the wall and dusting it with charcoal powder, the holes leaving a faint outline on the plaster.

The pigments had to be finely ground and mixed with just the right amount of water, a task that was generally the responsibility of assistants or apprentices.

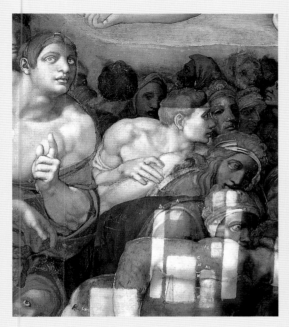 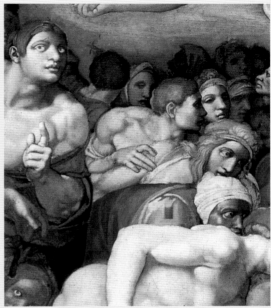

Corrections to the painting could only be done *al secco*, in other words when the plaster had dried (from the Italian *secco*, "dry"). Fresco secco, however, was far less permanent than true fresco.

The recent restoration work on Michelangelo's frescoes was necessary because over the centuries the paintings had become covered with soot, grease, and grime – not only from the candles and oil lamps used in the chapel, but more recently from city traffic.

To add to the problem, the frescoes had been covered in the 18th century with a thick layer of varnish intended to conserve them. A layer of dirt had accumulated on top of this varnish and the paintings looked as though they were hidden behind smoked glass. The cleaning has enabled the paintings to be restored to their original condition and we can now clearly see the sheer intensity of the colors Michelangelo used in decorating the Sistine Chapel.

To protect the paintings for the future, the Sistine Chapel is now air conditioned by a system which replaces the room's air at intervals of less than an hour, and which filters all incoming air.

The conservation process began with a light cleaning of the surface with water. Ammonium carbonate, a solvent, was then applied to the protective layers of Japanese paper that had been placed over the surface of the painting. After a few minutes the solvent and dirt were wiped away with a sponge soaked in distilled water.

Opposite, right; and above, left and right:
**Last Judgment** (detail)
1536–1541
Fresco
Rome, Vatican,
Sistine Chapel

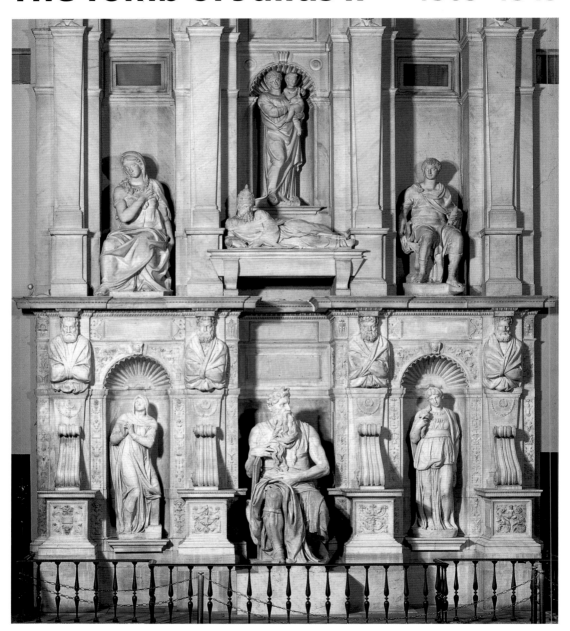

In 1505 Michelangelo received the most important commission of his early career. He was ordered to Rome by Pope Julius II, who awarded the artist, then barely 30 years old, with the contract to construct his tomb. However, Julius's ideas for a tomb on a monumental scale clashed with his ambitious plans for Rome, which he wanted to see revived in all its former classical glory.

Among his projects of urban renewal was the reconstruction of St. Peter's, a costly undertaking that finally forced him to set back his plans for his tomb. Thus began the most difficult and contentious of all Michelangelo's commissions. Not until many years after the pope's death, and after countless disputes with his heirs, was the tomb finally completed, in 1545.

**Martin Luther, 1528**

**Damned Man, ca. 1525**

**1517** Luther makes public his 95 Theses, which will precipitate the Reformation.

**1519** Death of Leonardo da Vinci.

**1523** The Medici Pope Clement VII succeeds Hadrian VI.

**1527** Rome sacked by the troops of Emperor Charles V.

**1531** Halley's comet appears.

**1543** Copernicus's writings on astronomy published.

**1545** First botanic garden in Padua.

**1505** Michelangelo invited by Pope Julius II to Rome; first contract for the Tomb of Julius II. He spends eight months in the quarries of Carrara selecting suitable marble for the tomb.

**1506** The *Laocoön* (page 74) is unearthed in Rome on January 14 in Michelangelo's presence. In April Julius II postpones the tomb project. Disappointed, Michelangelo hurries back to Florence.

**1513** Julius II dies on February 20. A new contract for the tomb is drawn up by the pope's heirs.

**1516** Third contract for the tomb. Michelangelo returns to Florence.

**1545** Tomb of Julius II erected in the church of San Pietro in Vincoli in Rome.

Opposite:
**Tomb of Julius II**
1545
Marble
Height ca. 850 x 670 cm
Rome, San Pietro in Vincoli

Right:
**Study for the Figure of Julius II for the Tomb of Julius II**,
ca. 1516
Pen on paper
21.2 x 14.3 cm
Florence, Casa Buonarroti

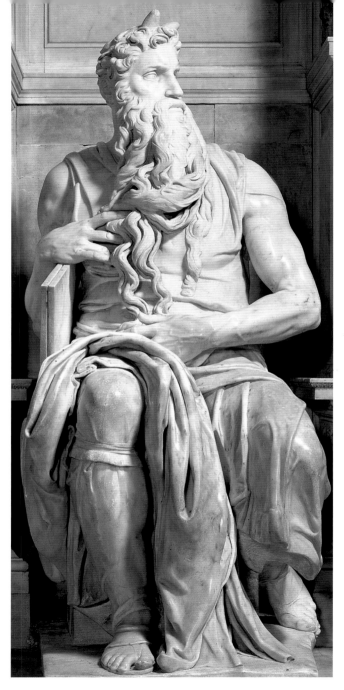

# The Story of the Tomb

Michelangelo worked on the tomb for Pope Julius II for just over 40 years. He himself claimed that "the tragedy of the tomb" had robbed him of his youth. Successive popes, all of whom insisted on employing Michelangelo on their own projects, prevented him from working steadily on the project.

Michelangelo's first design for the tomb proposed an enormous free-standing monument in the choir of St. Peter's; in all, 40 bronze statues and numerous bronze reliefs were planned to glorify Julius' deeds. Julius himself postponed the tomb project in favor of work on the papal

Left:
**Moses**, ca. 1515
Marble
Height 235 cm
Rome, San Pietro in Vincoli

The central statue of Julius II's tomb is *Moses*. The outsized figure is flanked by female embodiments of the active and contemplative life, Leah and Rachel.

Right:
**Leah (vita activa)**,
ca. 1542
Marble
Height 197 cm
Rome, San Pietro in Vincoli

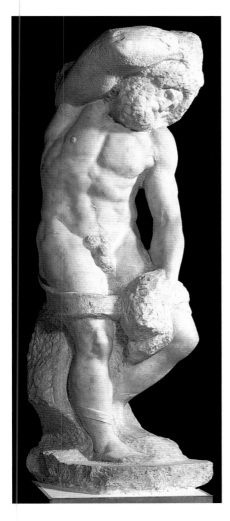

church of St. Peter's, and in 1508, as we have seen, he commissioned Michelangelo to paint the ceiling of the Sistine Chapel. When Julius died in 1513, shortly after completion of the Sistine Chapel frescoes, the construction of his tomb was once again on the agenda.

In the same year the executors of Julius II's will drew up a new contract with Michelangelo that provided for the monument to be reduced in scale, and to have fewer ornamental statues. Instead of a free-standing tomb, the grave was to be built into an existing wall. A third contract agreed to in 1516 lightened Michelangelo's burden still further by extending the completion date and reducing the dimensions of the tomb yet again.

In the following years, however, the Medici popes, Leo X and Clement VII, prevented Michelangelo from working on their predecessor's monument, engaging him to work for them instead. Two further contracts in 1532 and 1542, when the size of the tomb was again reduced, came during the pontificate of Paul III. It was finally erected in 1545 in the church of San Pietro in Vincoli – not in St. Peter's as originally intended. Only the three figures in the lower register – Moses, Leah, and Rachel – are by Michelangelo himself.

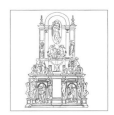

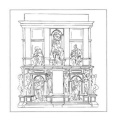

**Reconstructions of the designs of 1505, 1513, and 1516 for the Tomb of Julius II.**

While the first design for the tomb from 1505 was for a monumental, free-standing tomb, Michelangelo designed a more modest version in 1513 after the death of the pope. But even the scheme proposed in 1516, while greatly reduced in size, was never carried out.

**Bearded Slave**,
ca. 1520–1530
Marble
Height 263 cm
Florence, Galleria dell'Accademia

Initially the tomb of Julius was to have had 12 slaves symbolizing the soul captive in the body. Only six were begun and, of these, the four most fully worked are on display in the Galleria dell'Accademia in Florence.

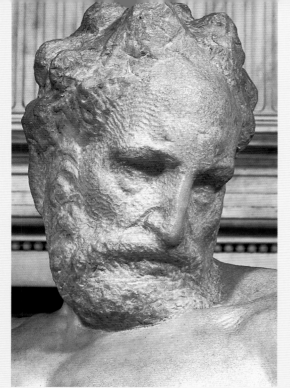

# "Michelangelo, Sculptor"

Michelangelo thought of himself first and foremost as a sculptor. One artistic activity common to both painting and sculptor, however, is drawing, and Michelangelo almost always began his work on a sculpture by drawing a range of studies.

Generally he captured his first idea for a sculpture in a small and hastily drawn figure sketch on paper (see the sketch for the *Bruges Madonna*, page 30). He refined this first draft in further sketches, often depicting the figure from various angles. Next he made a small scale, three-dimensional model. Such models, called *bozzetti*, were usually of clay, wax, or stucco (plaster). From the early 15th century artists used them not only as practical working models, but also as display models for clients, who often wanted to have a clear impression of the final product.

One of the unique features of Michelangelo's work seems to have been his use of very rough *bozzetti*, which he made in the same spontaneous way as he made his sketches on paper. He also made models in the original size, one of which has survived the centuries (below). This mock-up of a river god, which was

Above:
**Dusk (Il Crepuscolo)**,
(detail from the Tomb of Lorenzo de'Medici, Duke of Urbino)
Marble
Length 195 cm
Florence, San Lorenzo,

Right:
**Model of a River God, (Sagrestia Nuova)**,
ca. 1524
Clay, wood, wool etc.
Length 180 cm
Florence, Casa Buonarroti

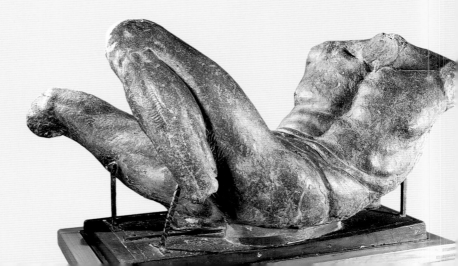

**Slave (Atlas),**
ca. 1530–1534
Marble
Height 277 cm
Florence, Galleria
dell'Accademia

intended for the Medici Chapel in Florence, was never completed in marble.

Michelangelo traveled personally to the quarries in order to select the most suitable marble, which was his preferred material. The actual sculpting normally began at the front of the figure.

The artist sketched the contours of the figure on the stone and then began chiseling out the most prominent parts of the body in rough form. He worked into the marble methodically, uncovering the deeper sections of the figure layer by layer. This procedure was similar to the technique of relief sculpture, in which layers of stone are also cut away one after the other.

Michelangelo's way of carving marble was very different from the method traditionally employed by Florentine sculptors. They did not work from one side of the figure, but kept moving around the block, carving one part then another. By doing so, by having a series of essentially partial views, they were never able to get a real sense of the figure before them as a single coherent entity. As a result, parts sometimes had to be attached after completion, and the figures are often out of proportion.

For Michelangelo, the task of the sculptor was to "release the figure trapped in the stone"; the essence of sculpture was the "power of taking away."

*No image may even the best of artists*
  *conceive,*
*Which the marble has not already surrounded*
*And embraced; and, to release it,*
*The hand, a willing tool, obeys the power of*
  *Creation.*

Michelangelo Buonarroti

# Michelangelo's *Slaves*

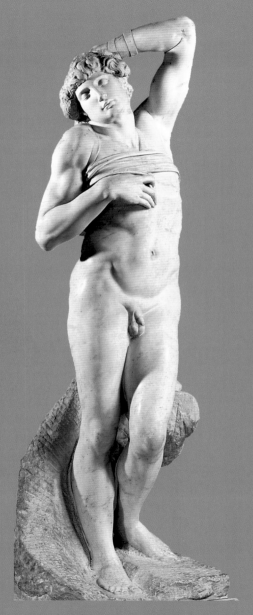

Michelangelo's *Slaves*, which are today housed in the Louvre in Paris, reached France as early as 1550. He had given them as a present to the Florentine banker Roberto Strozzi out of gratitude for Strozzi having taken care of him on two occasions while he was seriously ill in Rome. Strozzi took the sculptures into exile to Lyon and presented them to the French king, Francis I. The king in turn gave the statues to his commander-in-chief. They continued to change hands over the centuries until they were purchased by the French state in 1794, thus gaining a place in the Louvre.

The *Slaves* were originally intended for the second version of the Tomb of Julius II, which had been agreed upon in 1513, but they were then replaced by the two figures of *Leah* (page 54) and *Rachel*.

It is clear that Michelangelo had a particular attachment to these figures. Despite the fact that they were merely figures to frame the tomb, he started work on them first, together with *Moses*

(page 54). The debate about the meaning of the *Slaves* began almost as soon as they had been completed. Vasari speculated in 1550 that the two statues represented provinces subjugated by Pope Julius II; during the course of his pontificate, this warlike cleric had led various

**Sketch of a Slave**, ca. 1513
Ink
22 x 8 cm
Paris, Louvre

**Dying Slave**, ca. 1513
Marble
Height 229 cm
Paris, Louvre

campaigns against rebellious Italian territories governed by the Church. However, Michelangelo's assistant Condivi claimed in 1553 that they were connected with another aspect of the papal character, namely that of the art lover. He saw the figures as embodiments of the arts, who, with the death of the pope, had lost their patron and so were now in bondage.

An indication that the statues may indeed symbolize the arts is provided by the ape situated behind the so-called *Dying Slave*. In the Renaissance the expression *ars simia naturae* ("art apes nature") was common, and modern scholarship has tended to favor this interpretation.

The sculptures were first described as slaves in the 19th century, and they are still referred to as such today. Michelangelo himself called them simply *prigioni* ("captives"), and this is how he depicted them. While the hands of the *Rebellious Slave* are bound behind his back, the other still wears his bonds across his chest and on his left arm.

The two figures form a stark contrast: while one fights with all his might against the bonds, the other has surrendered meekly. The *Dying Slave* seems to wait patiently and serenely, and is about to rest his head, supported by his hand, on his shoulder. His right hand rests on the rope that is wound like a band around his breast, but not in order to tear at it. Relaxed and almost languid, this attractive youth looks as though he is drifting off to sleep rather than dying (the figure is also known as *The Sleeper*.)

By way of contrast, every muscle and sinew of the *Rebellious Slave* is stretched taut. He wrenches and turns, and thrusts his head forward – but is unable to loosen his bonds. The figure was left unfinished because of an unsightly flaw in the marble that runs from the right temple to the left shoulder.

The theme of spiritual imprisonment exercised a personal fascination for Michelangelo, and in his poems he often used the image of life as an "earthly prison."

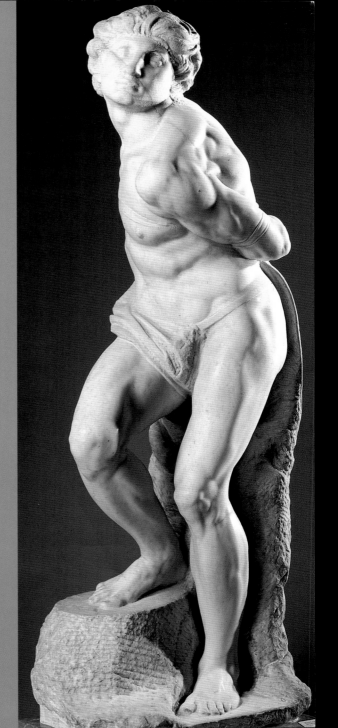

**Rebellious Slave**, ca. 1513
Marble
Height 215 cm
Paris, Louvre

# San Lorenzo    1516–1534

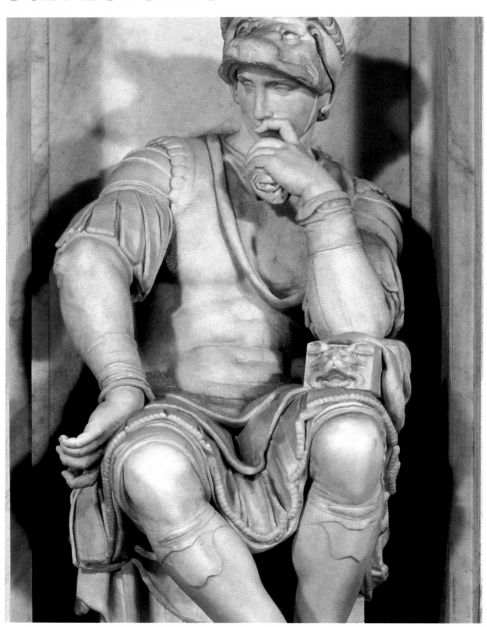

Michelangelo's first architectural commission from a pope was for a project in his (and the pope's) native Florence. Giovanni de' Medici was elected Pope Leo X in 1513 and, together with his cousin Giulio, later Pope Clement VII, forged great plans for the church of San Lorenzo in Florence, which lay close to the city palace of the Medici. The commission to build a magnificent façade that Michelangelo initially received was later withdrawn, but he did begin work on the funerary chapel of the Medici and on their library in Florence, the Biblioteca Laurenziana. He interrupted this work during the city's republican years from 1527–1530, when the Medici were overthrown and driven from the city. Although he had been in the service of the Florentine Republic and had taken a stand against the Medici, after their return to power he was pardoned by Clement VII and was able to resume work.

Opposite:
**Lorenzo de' Medici, Duke of Urbino**
(detail from his tomb), ca. 1525
Marble
Height 178 cm
Florence, San Lorenzo, Sagrestia Nuova

Right:
**Design for a Double Tomb for the Medici Chapel**, ca. 1521
Pen drawing
21 x 16 cm
London, British Museum

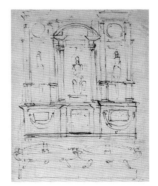

**Cortés lands in Mexico**

**Madonna and Child,** ca. 1525

**1516** Sir Thomas More publishes *Utopia*

**1517** Coffee and cocoa are introduced to Europe.

**1519** Hernando Cortés lands in Mexico with 600 mercenaries.

**1521** Spaniards destroy the Aztec capital of Tenochtitlán.

**1525** Charles V and Francis I go to war over Milan.

**1530** Florence besieged by troops of Charles V.

**1534** Ignatius of Loyola founds the Jesuit Order.

**1516** Michelangelo receives commission from Leo X for the façade of San Lorenzo in Florence.

**1517** Travels to the quarries of Carrara and Pietrasanta to procure marble.

**1520** The contract for the façade of San Lorenzo is withdrawn.

**1521** Work begins on the Medici Chapel.

**1524** Commissioned to build the Biblioteca Laurenziana.

**1524** He becomes chief fortification engineer for the Republic of Florence against the Medici.

**1528** Death of his favorite brother, Buonarroto.

**1530** The Medici return in the fall to Florence, and work resumes on the Medici Chapel.

**1532** Start of friendship with Tommaso Cavalieri.

# First Architectural Project

The architectural commission that Michelangelo received from Pope Leo X was an enormous project. The church of San Lorenzo had been left partly unfinished; it was now to have its plain façade decorated in a manner befitting the parish church of the Medici. For this project alone 12 larger-than-life statues in marble, six bronze figures, and seven large reliefs were initially planned.

Michelangelo spent three years in the quarries of Pietrasanta near Florence searching for marble blocks of just the right size and character. He even had a special road built to transport the stone to Florence. But two years after the contract had been signed, and long after Michelangelo had delivered the first design, the pope withdrew, leaving Michelangelo beside himself with rage. The project was never finished.

**Wooden model of the façade of San Lorenzo**, from a design by Michelangelo, ca. 1517
Florence, Casa Buonarroti

In addition to making various sketches for the façade of the church of San Lorenzo, Michelangelo constructed a clay model (since lost) before having this wooden model built from his plans. The sculptures and reliefs planned for the façade are absent. Michelangelo's design was revolutionary in that it clad the stepped form of the basilica in a square façade.

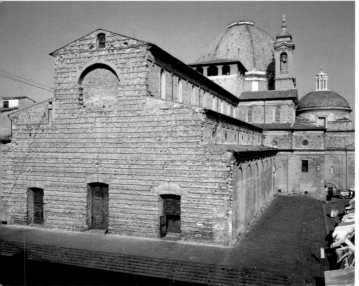

Filippo Brunelleschi
**San Lorenzo**,
Florence
Photo

The façade of the church of San Lorenzo in Florence had been bare since it was first built (and still is). It was to have been richly ornamented by Michelangelo; it would, in his words, "be a model for all Italy." The church, which dates from Roman times, had been comprehensively rebuilt by the architect Filippo Brunelleschi.

Preparations for the Biblioteca Laurenziana, which the Medici pope Clement VII had commissioned, went more smoothly. "For the general good," a fine library was to be built to house the Medicis' valuable collection of manuscripts.

The first signs of a Mannerist style are recognizable in the entrance hall. Here the window niches and decorative elements have been borrowed from the external architecture (right). By transferring such important features to the interior, Michelangelo seems to have been making a symbolic reference to the function of the library, which is designed to allow man to contemplate his inner life.

**Entrance hall of the Biblioteca Laurenziana**, from 1524 Florence, San Lorenzo

The walls of the high, square entrance hall to the library are divided into three sections by double columns. The vertical emphasis given to the walls by the high windows and columns is reinforced by pairs of massive consoles; they are purely decorative and have no load bearing function.

**Vestibule and stairway of the Biblioteca Laurenziana**, from 1524 Florence, San Lorenzo

After Michelangelo had already left Florence for Rome on the death of Pope Clement VII, his plans for the stairs in the entry hall to the library were completed by Bartolomeo Ammannati. With its rhythmic arrangement of oval and square steps divided into three sections, the stairway seems designed to draw the visitor into the library.

# The Power of the Popes

Raphael
**Portrait of Pope Julius II**,
1512
Oil on wood
108 x 80.7 cm
London, The National
Gallery

Michelangelo worked for no fewer than seven popes during his long career and was therefore an eyewitness to many far-reaching political and social changes.

The Reformation and Counter-Reformation of the 16th century confronted the papacy with a divisive internal crisis; and the rivalry between France and the Holy Roman Empire for dominance in Europe meant that the popes were continually embroiled in political conflict and diplomatic intrigue.

Michelangelo's first papal patron, Julius II, was himself the epitome of that art-loving Renaissance papacy that was steeped in humanist thought. This most martial of popes had led campaigns to win back rebellious territories for the Church, but he was also an outstanding patron of the arts. He intended the Eternal City to again blaze forth in all its former classical glory, for he thought of his office as the heir to a classical Roman tradition. Under Julius II, Rome became the foremost cultural center

during an epoch that contemporaries described as the Golden Age. He also advocated reform in all areas of the Church.

His successor, Leo X, a Medici, had known Michelangelo all his life. The young artist had at that time been a favorite of his father, Lorenzo de' Medici, and had lived in the family's Florentine palace. In matters of art, however, the refined Leo preferred the more delicate work of Raphael; Michelangelo's turbulent and unpredictable temperament was alien to him.

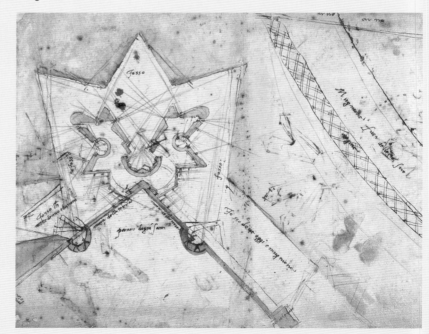

**Design for Fortifications
of the Porta al Prato
d'Ognissanti in Florence**,
1529
Pen with traces of red chalk
on paper
41 x 57 cm
Florence, Casa Buonarroti

Titian
**Portrait of Pope Paul III with his nephew**, 1545–1546
Oil on canvas
200 x 173 cm
Naples, Museo Nazionale di Capodimonte

Titian
**Portrait of Emperor Charles V**, 1548
Oil on canvas
205 x 122 cm
Munich, Bayerische Staatsgemäldesammlungen, Alte Pinakothek

Leo was by no means averse to earthly pleasures, and he is often seen by modern historians as a likeable bon viveur. He maintained a large court – it included actors, poets, clowns, and even elephant keepers – and this placed a great strain on the Vatican's finances. He also had to face political problems.

During his pontificate, the Reformation began to gather momentum; Martin Luther made his 95 Theses public in 1517. In 1519, Charles V was elected Emperor of the Holy Roman Empire, which was unfortunate for Leo's foreign policy. The Holy Roman Empire, which consisted mainly of German states, was now united with Spain, forming a political power that posed a serious threat to the many petty states of the Italian peninsula.

Leo's cousin, Clement VII, succeeded to the papal throne in 1523, but his indecisiveness and lack of political skill led to his being trapped between opposing forces. In 1527 he was unable to prevent the so-called Sacco di Roma, the brutal sacking of Rome by imperial mercenaries; Clement VII himself became a prisoner of Charles V. The Florentines now seized the opportunity of emancipating themselves from Medici rule and set up a republican government. As we have seen, Michelangelo threw in his lot with the republicans and even worked to build the city's defenses against the Medici.

However, when the pope and emperor were reconciled in 1530, and Medici rule was re-established in Florence, Clement pardoned Michelangelo and took him into his service once again.

After Clement's death in 1534, Michelangelo worked for Pope Paul III. Paul labored to stabilize the Church, which had been gravely weakened by the Reformation, and he was active as a diplomat in negotiations between Emperor Charles V and the French king, Francis I. It was also during his pontificate, in 1545, that the Council of Trent, which initiated the reform of the Catholic

Raphael
**Portrait of Pope Leo X with Cardinals Giulio de' Medici and Luigi de' Rossi**, 1518–1519
Oil on wood
154 x 119 cm
Florence, Uffizi

Church – the Counter-Reformation – was convened.

Michelangelo was not always a very willing artist for his papal clients. His fiery temperament sometimes led him into dangerous situations that he was ultimately able to weather only because the popes recognized his tremendous creative genius.

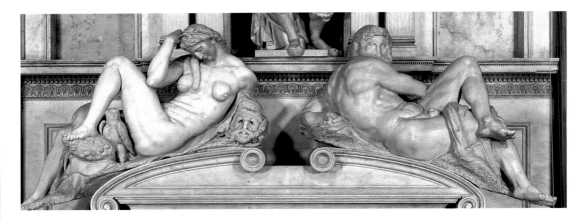

# The Medici Chapel

The construction of the Medici Chapel was probably spurred on by the death of 28-year-old Lorenzo de' Medici, the Duke of Urbino; his demise signaled the end of the main branch of the family line. The Medici popes Leo X and Clement VII had commissioned Michelangelo to erect their family tomb in the church of San Lorenzo in Florence. Cosimo the Elder, 1389–1464, had already been buried in Brunelleschi's Sagrestia Vecchia (Old Sacristy) in the church. As a counterpart, the Sagrestia Nuova (New Sacristy) on the opposite or northern side of the choir was to be the resting place of other Medici family members.

After the pope rejected an initial plan, Michelangelo planned wall graves on three sides of the chapel. On the wall opposite the altar stands the tomb of Lorenzo de' Medici the Magnificent, and of his brother Giuliano. The side walls are decorated with the graves of two of the younger Medici, Lorenzo, Duke of Urbino, and Giuliano, Duke of Nemours.

Like much of Michelangelo's work, the Sagrestia Nuova remained unfinished, for in 1534 he moved permanently to Rome. The least unfinished pieces are the tombs of the young dukes, Lorenzo and Giuliano; the *Medici Madonna*; and statues of two saints, Cosmas and Damian

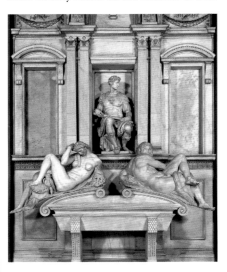

Above and below:
**Tomb of Giuliano de' Medici, Duke of Nemours**, 1526–1531
Marble
Florence, San Lorenzo, Sagrestia Nuova

Michelangelo positioned the graves of the two Medici dukes symmetrically on opposite walls of the chapel. The young Giuliano de' Medici, Duke of Nemours, clad in antique armor, is seated on a throne in a niche framed by double pilasters. The personifications of Day and Night recline on two clasp-shaped volutes. Night (left) appears withdrawn and lost in thought, while Day (an unfinished sculpture) raises his head to welcome the dawn.

(though these two works were not executed by Michelangelo himself). Various figures on parts of these tombs were left unfinished. There were also originally four river gods, which would probably have been positioned at the feet of the sarcophaguses.

Lorenzo and Giuliano are depicted in antique armor and embody opposites: Lorenzo represents the active life, Giuliano the contemplative life. The allegorical depictions of the times of day (Day and Night) refer to the passage of human life. The spiritual focus is the pensive Madonna, who seems barely able to hold an agile infant Jesus (left). As in other treatments of this theme (such as the *Taddei Tondo*, page 27) Michelangelo creates a contrast between the vitality of the child and the knowing and pained foresight of the mother.

Left and above:
**Medici Madonna**,
1521–1534
Marble
Height 226 cm
Florence, San Lorenzo, Sagrestia Nuova

The Madonna, whose child turns to her for protection, decorates the grave of Michelangelo's first patron, Lorenzo de' Medici, and his brother Giuliano, who was murdered in 1478 during the Pazzi Conspiracy.

Right:
**Interior of the Medici Chapel**
1521–1534
Florence, San Lorenzo, Sagrestia Nuova

The structuring elements of gray *pietra serena* stone form a tight grid of vertical and horizontal lines on the walls of the chapel; the grayish-black sandstone contrasts sharply with the white plaster of the walls and the brilliant marble of the tomb's monuments. The least complete tombs are those of Lorenzo the Magnificent and his brother Giuliano, on the entrance wall (on the left of the picture). The three statues have no framing devices, but occupy the most prominent position in the chapel, opposite the altar.

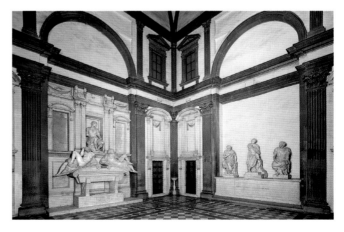

# Michelangelo and Mannerism

The term Mannerism is used for the style that flourished between the Renaissance and the Baroque periods, that is, from around 1520/30 to around 1600. The word *maniera* had been used in Italian art theory since the 14th century. In general it meant the personal style of an artist, but was also used to refer to the style of an era. For example, in his *Lives of the Most Excellent Artists, Sculptors, and Architects* (1550), Giorgio Vasari wrote that Michelangelo's many imitators and followers worked "alla maniera di Michelangelo" – in the style of Michelangelo.

Today, the term Mannerist is used to refer to those artists who reacted to the great masters of the High Renaissance by setting out to find a completely new style. Modern scholarship traces the development of Mannerism back to two essential causes. First, far-reaching social and religious changes and disruptions: the teachings of the Reformation profoundly challenged traditional religious beliefs, and the sacking of Rome by Imperial troops in 1527 led to doubts throughout Italy about the strength of the papacy as a political force. Second, as we have seen, the Mannerist style can be seen as a direct result of the struggle of a generation of young artists to come to terms with the overpowering influence of the great masters preceding them. Artists such as Michelangelo, Leonardo, and Raphael were thought to have achieved such a degree of perfection and artistry in virtually all areas that young artists felt that they could not develop art further, that they had nothing new to say in the style of the High Renaissance.

The new, restlessly dynamic style was a reaction against the classical ideals of harmony and clarity. Many of Mannerism's exceedingly complex compositions are marked by a disharmony

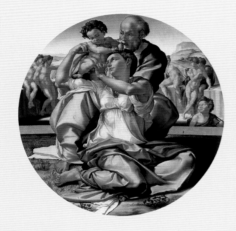

Jacopo Pontormo
**Entombment**
1525/1526–1528
Oil on wood
313 x 192 cm
Florence, Santa Felicità

Left:
**Holy Family (Tondo Doni)**,
1503–1504
Tempera on wood
Diameter 120 cm
Florence, Uffizi

and internal tension far removed from naturalistic representation.

The ideal forms and proportions developed during the Renaissance were felt to be too rigid, and were therefore deliberately deformed and exaggerated. Works such as Michelangelo's *Doni Tondo* (opposite left, and page 29), in which the skillfully depicted twists and turns of the figures were used to express the artist's originality rather than simply to depict a particular situation, were considered the beginnings of Mannerism. Mannerists rejected the pyramidal compositions used by Michelangelo, an achievement of the High Renaissance, in favor of more complex and unstable compositions.

The painter Jacopo Carrucci (1494–1557), known as Pontormo, was greatly influenced by Michelangelo's work; his *Entombment* (opposite) shows a highly complex figurative structure in which the spatial relationships of the individual figures are unclear. In contrast to the works of earlier artists, the central focus of this picture is simply a piece of material held up by one of the figures: Jesus and Mary have been displaced from the center of the image.

The radically twisted figure, in a pose known as *figura serpentinata*, also belongs to the decorative and artistic repertoire of the Mannerists. Michelangelo's statue *Victor* (right), made for the Tomb of Julius II, already displayed such a form, with the S-shape of the body twisting around a vertical axis.

The *figura serpentinata* was stylized still further by the sculptor Giovanni da Bologna (1529–1608), as his *The Rape of the Sabines* (left) shows; here all three figures demonstrate this twisting movement. A characteristic of this Mannerist figurative type is the way in which it can be viewed from all sides; when we walk around such a sculpture, new views open up as our angle of vision changes. The frontal view that had dominated during the Renaissance had been eliminated.

**Victor**, ca. 1520–1525
Marble
Height 261 cm
Florence, Palazzo Vecchio

Left:
Giovanni da Bologna
**Rape of the Sabine Women**
1581–1583
Marble
Height 410 cm
Florence, Piazza della Signoria, Loggia dei Lanzi

In 1534, Michelangelo finally settled in Rome, where he spent the remaining 30 years of his life. After the death of Clement VII in 1534, he was immediately taken into the employ of the new pope, Paul III.

Now nearly 60, Michelangelo received a major commission to paint the vast altar wall of the Sistine Chapel. Impatient to see Michelangelo working for him at last, Paul III is said to have cried: "I have harbored this fervent wish for 30 years, and, now that I have become pope, am I not to see it fulfilled?" He named Michelangelo "Chief Architect, Sculptor, and Painter of the Apostolic Palace." The "divine Michelangelo" was now at the peak of his fame, his work setting the artistic standard for all Italy.

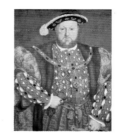

**Henry VIII, King of England**

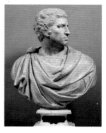

**Brutus, ca. 1538**

**1534** Death of Pope Clement VII; he is succeeded by Alessandro Farnese, who takes the name Paul III.

**1535** Diving-bell invented. Spain founds Buenos Aires.

**1536** Henry VIII orders the execution of his second wife, Anne Boleyn.

**1541** John Knox establishes the Calvinist Reformation in Scotland.

**1534** Michelangelo's father dies; the artist settles in Rome.

**1535** Michelangelo is named Chief Architect, Sculptor, and Painter of the Vatican by Pope Paul III.

**1536** Begins work on the fresco *The Last Judgment* in the Sistine Chapel. Meets Vittoria Colonna, whose poems are published in the same year.

**1537** Michelangelo is made an honorary citizen of Rome.

**1541** *The Last Judgment* is unveiled on December 25.

Opposite:
**Christ and Mary**
(detail from *The Last Judgment*),
1536–1541
Fresco
Rome, Vatican, Sistine Chapel

Right:
**Self-portrait of Michelangelo on the flayed skin of St. Bartholomew**
(detail from *The Last Judgment*),
1536–1541
Fresco
Rome, Vatican, Sistine Chapel

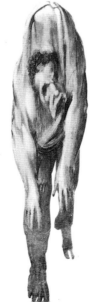

# The Last Judgment

Michelangelo's theme for Paul III's enormous fresco in the Sistine Chapel was the Last Judgment, which it was thought would occur at the end of time, when Christ came to judge the living and the dead. The wall is occupied by more than 390 figures, some of them being over two meters (six-and-a-half-feet) high. In this tangle of naked bodies it is difficult to distinguish mortals, angels, and saints from one another. The angels are without wings, and the saints are identifiable only by the attributes of their martyrdom instead of the traditional halo.

Surrounded by angels and saints, Christ is seated on a throne in the bright glow of an aureole, his arm raised in command, while Mary rests gently against him. At the bottom left, the saved rise from their graves and ascend to Heaven supported by angels. On the right, the damned are rowed across the Styx by Charon. Awaiting them are terrifying demons as well as King Minos, who in Greek mythology is the king of the Underworld; he is portrayed with ass's ears, and wearing a serpent as a girdle.

Following a decision by the Council of Trent, Michelangelo's pupil Daniele da Volterra was later commissioned to conceal the nakedness of the figures. He performed this task so carefully that very little damage was in fact caused to Michelangelo's work. At the time of the last major conservation project, the decision of this 16th-century council was adhered to, and the extra layers of paint were not removed.

Opposite:
**The Last Judgment**
1536–1541
Fresco
1370 x 1220 cm
Rome, Vatican,
Sistine Chapel

Michelangelo decided not to frame this vast mural; it therefore appears to the viewer as just one small section of an uninterrupted event that spreads out over the chapel walls.

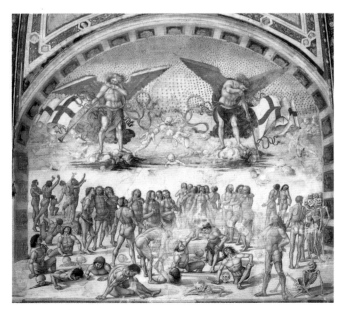

Luca Signorelli
**The Damned** (detail)
1499
Fresco
Orvieto Cathedral,
San Brizio Chapel

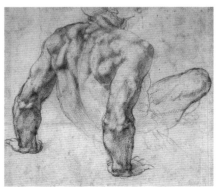

**Male Nude**
Study for one of the resurrected
in *The Last Judgment*
29 x 23 cm
London, British Museum

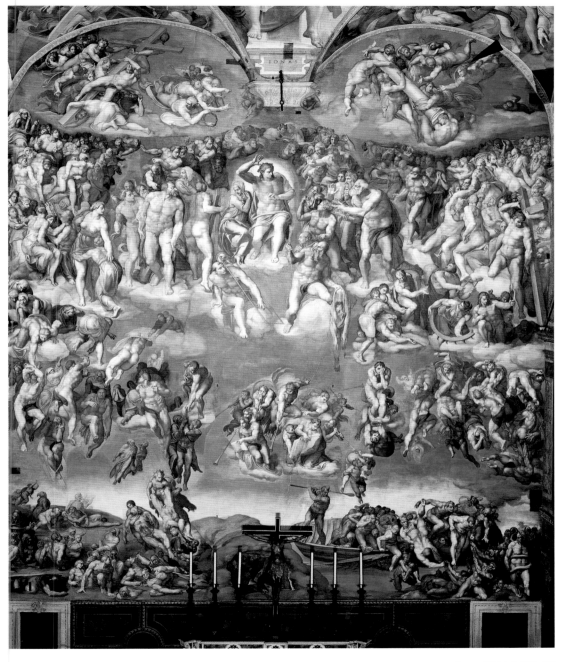

# Michelangelo and Antiquity

Michelangelo's interest in the world of classical Greece and Rome began in his youth, when he had the opportunity to study the collection of antiquities belonging to the Medici in their gardens near San Marco. As a guest in the Medici household, he was able to move in the circles of scholars who frequently visited the palace; their knowledge of classical literature and philosophy clearly had a great influence on the young artist. One of his very first works, his *Battle of the Centaurs* (page 12), vividly demonstrates his early interest in classical themes.

In Rome he also had access to other important collections of antiquities. In 1496 he became acquainted with two of the city's most influential collectors: the banker Jacopo Galli, one of his most important patrons;

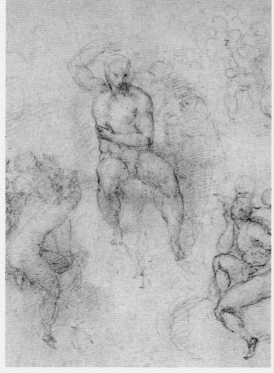

and Cardinal Riario, for whom he probably carved his *Bacchus* (page 20).

This portrayal of the Roman god of wine was the first of Michelangelo's monumental sculptures, and was considered so close to classical statuary that in the 16th century it was placed in the antiquities section of the Medici collection.

For the generation of artists preceding Michelangelo, the classical age served as a spiritual and artistic model. Donatello, Mantegna, and Verrocchio had all learned how to depict the human form

Agesander
**Laocoön**
ca. 50 BC
Marble
Height 242 cm
Rome, Vatican, Museo Pio-Clementino

Left:
**Christ in Judgment**
Study for *The Last Judgment* (detail)
Chalk drawing
34.5 x 29 cm
Florence, Casa Buonarroti

realistically by studying the sculptures of ancient Greece and Rome. Classical sculptures were admired for their perfect proportions, their anatomical precision, and their ideal beauty, all qualities Renaissance artists strove to emulate. Michelangelo's relationship with these ancient works was of another order. Not only did he adopt and then reinterpret certain themes, as with his *Bacchus*, he also adopted certain formal motifs – such as posture and movement – that he used in his own works. Under Pope Julius II, the most superb

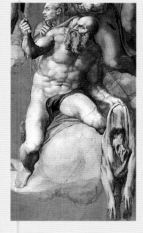

finds that contemporary archeology had brought to light were exhibited in the Belvedere Court of the Vatican Palace. The *Laocoön* group (opposite, top right) had been found in a vineyard near the Coliseum in 1506. The violent movement of Laocoön captures a critical point in his death struggle with two giant snakes. This pose

recurs as a motif in a number of Michelangelo's works, particularly in the figure of Christ in *The Last Judgment* and in preparatory drawings (opposite, bottom left).

The torso of *Ajax* by Apollonios (right) had been known from the 15th century and was displayed in the Belvedere Court from the pontificate of Clement VII onwards. Known as the *Belvedere Torso*, it provides an interesting example of the way in which classical works were regarded during the Renaissance. For though the disposition of the entire body can only be guessed at – the head and limbs are missing – the torso often featured in the works of Renaissance artists because of its tense, concentrated power.

The twisted attitude of the shoulders, which contrasts with the position of the lower body, was recognized as being both an accurate rendering of anatomy, and also a simultaneous depiction of action and rest reduced to its expressive essentials. Michelangelo made frequent use of this posture in the ceiling frescoes of the Sistine Chapel and in *The Last Judgment*; the figures of sibyls, prophets, and *ignudi* are often portrayed in this position. Even St. Bartholomew, who holds his own flayed skin bearing a self-portrait of Michelangelo (left), is pictured with precisely this twisted movement of the torso, his muscular abdomen closely

resembling the classical model from which Michelangelo had drawn his inspiration.

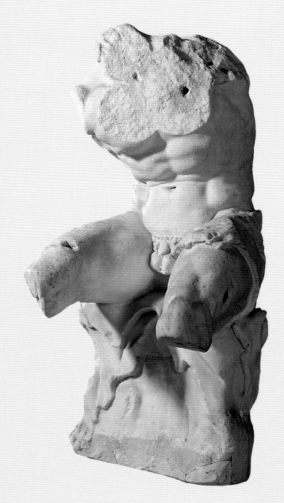

Apollonius
**Ajax (Belvedere Torso)**
ca. 50 BC
Marble
Height 224 cm
Rome, Vatican Palace, Museo Pio-Clementino

Left:
**St. Bartholomew**
(detail from *The Last Judgment*)

# Presentation Drawings

It was not until late in life that Michelangelo cultivated close friendships. He had always lived alone and for his art; at most, he had a servant for company.

In 1532, however, he began a very close and intense relationship with a young Roman nobleman, Tommaso Cavalieri, that lasted until the artist's death. A number of drawings Michelangelo made for Cavalieri were intended to introduce the younger man to the art of drawing. These illustrations deal with themes from ancient mythology such as the Fall of Phaeton, three versions of which have survived.

On the drawing now in the British Museum, Michelangelo added the comment: "Dear Mr Tommaso, should you find this sketch wanting, convey it to Urbino [Michelangelo's servant] so that I may have time to make another by tomorrow evening, as I promised; but should it please you, and you wish me to complete it, send it back to me."

The drawing shows the Greek mythological figure

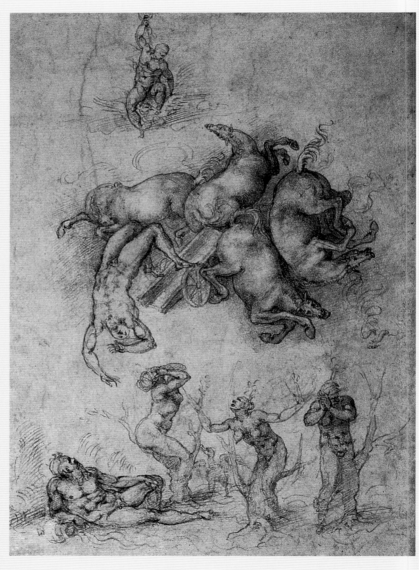

**Fall of Phaeton**, 1533
Charcoal on paper
31.3 x 21.7 cm
London, British Museum

**Andrea Quaratesi**, ca. 1532
Charcoal on paper
45.8 x 33.2 cm
London, British Museum

Phaeton at the moment he loses control over the horses of the Sun Chariot, which he had borrowed from his father, the Sun, and plummets into the river Erdanus. Zeus appears at the top hurling thunder bolts, while below Phaeton's sisters are being transformed into poplars for having harnessed the horses. On the left is a river god.

As well as addressing a large number of sonnets to Cavalieri, Michelangelo is said to have made a life-sized drawing of the young man, whom contemporaries described as extraordinarily handsome; this drawing, sadly, has not survived. The only known portrait by Michelangelo depicts the Florentine Andrea Quaratesi (above), whom the artist had known from childhood.

Besides Cavalieri, the aristocrat Vittoria Colonna, Marchesa of Pescara, was one of the most important

people in Michelangelo's later years. The artist worshipped the marchesa, dedicating poems to her and sending her drawings as tokens of his admiration and affection. This highly educated woman wrote poetry herself, and exchanged ideas with the most famous men and women of her age. She also conducted a lively intellectual dialogue with Michelangelo; their discussions on art, which were often held among a wider circle, were recorded by the Portuguese miniaturist Francesco de Hollanda.

It was through Vittoria Colonna that Michelangelo, who became increasingly interested in religious questions as he grew older, was brought into contact with the so-called Italian Reformation. Inspired by the Reformation in northern Europe, the aim of this movement was the complete renewal of religious faith. Michelangelo never got over the death of Colonna in 1547. His assistant and biographer, Ascanio Condivi, writes that he had heard his master say, "nothing can cause me so much sorrow as when I went to see her departing from this life, and did not kiss her on the brow or face, just as I had kissed her hand."

The presentation drawings for Tommaso Cavalieri and Vittoria Colonna have in common a high degree of finish and a fine, subtle style designed to have the fullest impact when viewed from

close up. Cavalieri's drawings are concerned with secular themes; while those Michelangelo gave the more spiritual Colonna are of religious subjects. The demand for drawings by Michelangelo was always great; some of those made for Vitorria Colonna were copied and reproduced with print techniques during the artist's lifetime.

**Pietà**, for Vittoria Colonna, 1538–1540
Chalk on paper
29.5 x 19.5 cm
Boston, Isabella Stuart Gardner Museum

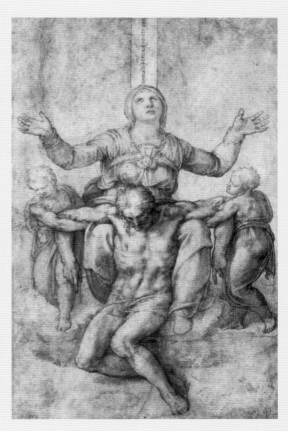

# The Later Works   1542–1564

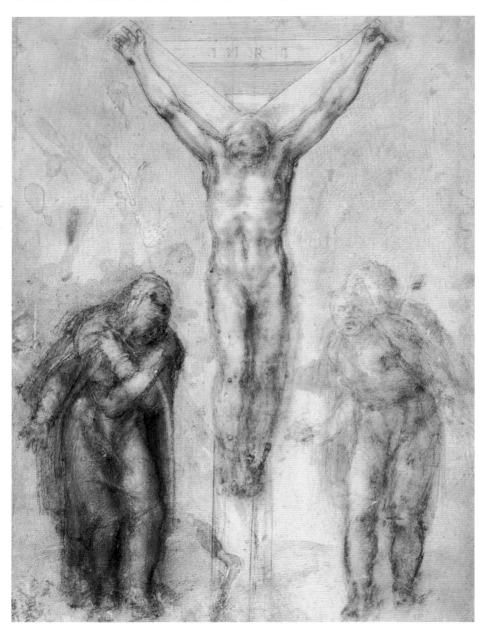

In his later years, Michelangelo turned his attention to architecture again. From Pope Paul III, with whom he was on good terms, he received two major commissions: to develop St. Peter's and to rebuild the Capitol.

Although a wealthy man, Rome's busiest artist lived in a modest house in the Macello dei Corvi near Trajan's Forum. His assistant Ascanio Condivi records him as saying: "As rich as I have become, I have always lived like a poor man." The greater part of his fortune went to maintain his family in Florence, for whom he bought property and houses. And when Michelangelo's faithful servant Urbino died, his widow and children were able to rely on Michelangelo's support for many years.

**The Council of Trent, 1545–1563**

**Bust of Michelangelo**

**1542** Founding of the Holy Office of the Tribunal of the Inquisition.

**1545–1563** Council of Trent meets as a reaction to the Reformation.

**1546** Building of the Louvre in Paris is begun.

**1548** The potato is introduced to Europe.

**1550** First edition of Vasari's *Lives of the Most Excellent Painters, Sculptors, and Architects* appears.

**1555** Nostradamus publishes his astrological predictions.

**1556** Coronation of Philipp II of Spain.

**1547** Death of Vittoria Colonna; Michelangelo named architect of St. Peter's in Rome.

**1550** Completion of the frescoes in the Cappella Paolina.

**1555** Francesco Urbino, his servant and assistant, dies. Michelangelo turns down an offer to work for Duke Cosimo de' Medici in Florence.

**1564** Michelangelo dies on February 18 at almost 89 years of age, and is buried in the church of Santa Croce in Florence.

Opposite:
**Crucifixion with the Virgin and St. John**, 1545–1550
Charcoal and white pigment
41.3 x 28.6 cm
London, British Museum

Right:
**Study for the Porta Pia**
ca. 1561
Charcoal, pen and brown ink, white gouache
44.2 x 28.1 cm
Florence, Casa Buonarroti

# The Cappella Paolina

"These paintings were his last, and he told me that it took a great effort to finish them. For when one has passed a certain age, one should no longer practice the art of painting, and especially the art of fresco painting." So wrote Giorgio Vasari about the frescoes Michelangelo painted in the Cappella Paolina.

Michelangelo was 75 years old when he finished the monumental murals in Pope Paul III's recently built private chapel, the Cappella Paolina; illness had constantly prevented the aging painter from continuing his work. The two paintings, on opposite side walls of the chapel, show scenes from the lives of the Apostles Paul and Peter, both of whom were of great importance to the pope – Paul as his namesake and Peter as the founder of the papal office.

The bare landscape, bereft of vegetation, is typical of Michelangelo's style; he preferred to concentrate on the human form, which he depicted in the most diverse poses and actions. Unusual for his work, yet an indispensable part of the subject, are the horses – animals of any description appear only rarely in Michelangelo's work.

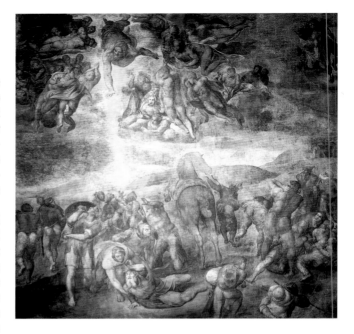

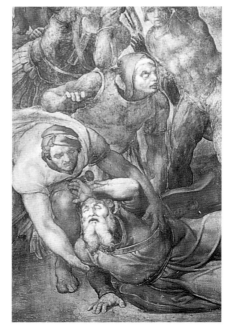

**Conversion of St. Paul**, ca. 1542–1545
Fresco
625 x 661 cm
Rome, Vatican, Cappella Paolina

Before his conversion, the Apostle Paul, then called Saul, was a committed enemy of Christianity. According to biblical tradition, he was blinded on the road to Damascus and fell to the ground, where he heard the voice of Jesus Christ speaking to him from Heaven. The dramatic gestures of the figures emphasize the emotion of the scene.

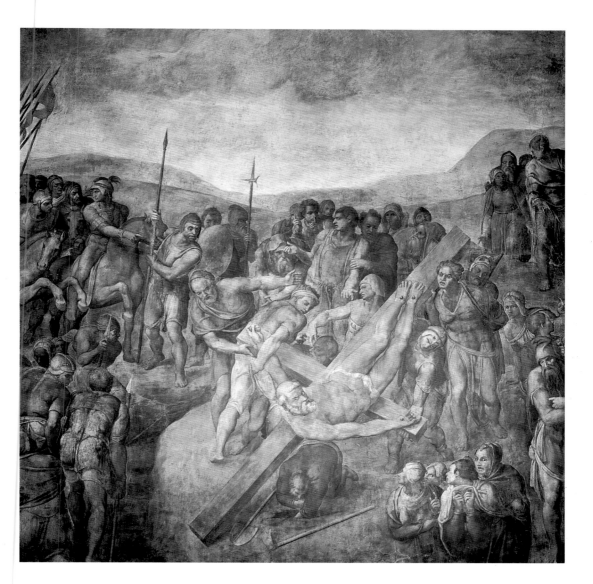

**Crucifixion of St. Peter**,
ca. 1545–1550
Fresco
625 x 662 cm
Rome, Vatican,
Cappella Paolina

The Apostle Peter, condemned to die on the cross, was crucified upside down at his own request. Michelangelo depicts the cross being raised up – this innovative composition avoids the problem of showing the saint in an undignified position. The viewer is drawn into the scene subtly: the gaze of the saint is directed at the viewer, who thus closes the narrow circle surrounding the martyr.

# Palazzo Farnese and the Porta Pia

After the death of the architect Antonio da Sangallo the Younger in 1546, Michelangelo was commissioned by Paul III to continue the reconstruction of the pope's family palace in Rome, the Palazzo Farnese. Michelangelo made several far-reaching alterations of the original plans; in particular he introduced a colossal scale to the design, so that the dimensions of the Palazzo Farnese overshadowed those of all other contemporary Roman palaces. The then unfinished second story was increased in height, so that the façade became more imposing; the cornice at the top of this floor was of an unprecedented height, enabling Michelangelo to ornament it in such a way as to produce startling effects of light and shade. He also proposed a plan for a spectacular

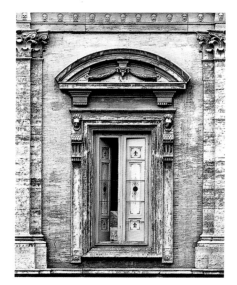

**Top-floor window of the Farnese Palace, Rome**

The courtyard windows of this gracious palace are particularly rich in ornamentation. Based on Michelangelo's plans, the windows on the uppermost floor are decorated by an opulent segmental pediment with a garland and ram's head. The window frames feature lions' heads and volutes.

**Façade of the Palazzo Farnese**
Photo, Rome

The massive and majestic 46-meter (150-foot) wide façade of the Farnese Palace is divided horizontally into three distinct floors and vertically into 13 bays. The windows form the most prominent element of the façade. The palace was the result of the work of several architects; its reconstruction was begun by Antonio da Sangallo the Younger, continued in a radically altered form after his death by Michelangelo, and finally completed in 1580 by Giacomo della Porta.

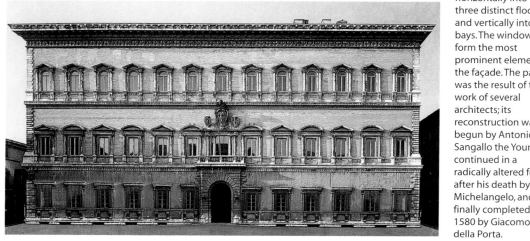

B. Faleti
**Porta Pia**, 1568
Copperplate
engraving

This engraving
documents the city
gate around 1568.

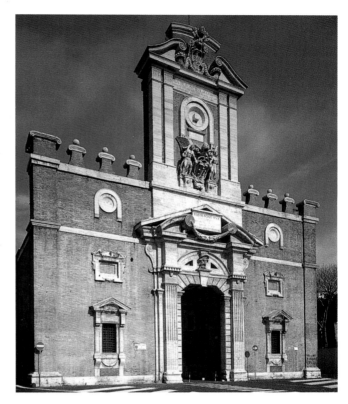

vista stretching from the courtyard of
the palace through the garden – which
featured a recently unearthed antique
sculpture, the so-called *Farnese Bull* –
and across the Tiber to gardens on the
other side of the river. This plan was
never put into action. On the death of
Paul III, Michelangelo seems to have
abandoned work on the palace, which
was completed in 1580 by Giacomo
della Porta.

Nor was the Porta Pia, a gate-
way into the city, completed by
Michelangelo himself, though the
portal, along with the blind windows
and ground-floor windows, are
attributed to his plans. He is also said
to have designed the cornice and the
crenellations, which were topped with
spheres that referred to the Medici
coat of arms (which consisted of a
shield with seven balls).

Michelangelo broke with tradition
by orienting the façade of this city
gateway inwards rather than
outwards, as was the custom.
However, the road on which the
gateway stands was then largely
uninhabited and lay between vine-
yards and gardens; in other words,
Michelangelo's structure had a deco-
rative character, and was meant to be
seen from the city itself.

**Porta Pia**, Façade of
the city gate, begun
1561
Photo
Rome

Michelangelo's Porta
Pia stands at the far
end of the Via Pia
(today the Via XX
Settembre) in the
north of the city. The
Via Pia and the Porta
Pia were both
commissioned by
Pope Pius IV and are
named after him.
Planning for this city
gateway began in
1561 but it was

completed only after
Michelangelo's death.
The changes made to
his original design
can be seen from
Faleti's engraving
from 1568 (above
left). The brick gate
had no defensive
function and was
purely a decorative
structure. It played an
important historical
role during the fight
to unify Italy in the
19th century: Imperial
troops stormed the
papal stronghold of
Rome through the

gate, subsequently
declaring the city the
capital of the Italian
Republic.

# The Capitol

The Capitoline Hill, the smallest of Rome's seven hills, was of immense significance for the city in classical times. The most important Roman temples were located there, and it was there that in classical times the triumphal processions of victorious armies ended. But the Capitol was neglected for centuries and finally became so run down that, when Emperor Charles V arrived in Rome in 1536, it was no longer considered fit to receive him. The emperor and his entourage were forced to go around the famous hill, a fact that was probably the decisive factor in the pope's decision to have the area rebuilt.

Pope Paul III donated the equestrian statue of the Roman emperor and philosopher Marcus Aurelius to the Senate. This statue, one of the most important works of classical sculpture, was set up on the Capitol on Michelangelo's instructions. The first step in the redesigning of the Capitol was the erection of this statue in the center of the still unleveled square. Immediately behind the statue was the medieval municipal Senate and, on the right, the Palazzo dei Conservatori, or city hall, dating from the 15th century. In 1537 Michelangelo was awarded honorary Roman citizenship in a ceremony that took place on the Capitol.

His task of redesigning the square was an example of what would today be called urban planning. His solution to this new challenge was discreet and uniquely elegant; significantly, it required little alteration of the existing architectural fabric, which had developed organically over several centuries. He preserved the

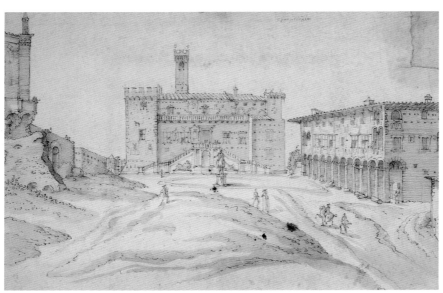

Italian School
**View of the Capitol**
(before its alteration by Michelangelo), ca.1554–1560
Etching
Paris, Louvre, Cabinet des Dessins

Before the Capitol was redesigned from Michelangelo's plans, it had a rather sad and neglected air; because there were no steps up to the hill, it could be reached only by climbing narrow paths.

Etienne Dupérac
**The Capitol**, ca. 1569
Copperplate
engraving from
designs by
Michelangelo

The antique
equestrian statue of
Marcus Aurelius in the
center is clearly the
focal point of the
square. Michelangelo
designed new façades
for both the municipal
Senate (at rear) and the
city hall, the Palazzo
dei Conservatori
(right). For reasons of
symmetry, he also
planned the Palazzo
Nuovo on the left as a
pendant to the Palazzo
dei Conservatori ;
today it houses the
Capitoline Museum.
Construction of the
Palazzo Nuovo began
while Michelangelo
was still alive but was
completed only after
his death. His plans,
however, were
followed closely.

Below:
**The Capitol**
Photo

relationship between the municipal
Senate and the Palazzo dei
Conservatori, designing new façades
for both buildings. Then, consistent
with his favored principle of sym-
metry, he built a third palace on the
left of the square as a counterpart to
the Palazzo dei Conservatori. As with
so many of his architectural plans,
most of the work was completed after
his death; the oval in the center of the
square with star motif was not in fact
realized until 1940.

# St. Peter's

At the age of 72, Michelangelo was appointed architect of the most famous church in Christendom, St. Peter's in Rome, by Pope Paul III. The patron saint of the church, the Apostle Peter, had been martyred in Rome by Emperor Nero; as the first bishop of Rome he was considered to be the predecessor of all the popes and the guarantor of their role as supreme head of the Church.

The first church to bear this name was built in the 4th century, and dedicated by Pope Sylvester in 326. After the exile of the popes to Avignon and the Great Schism in the 14th century, the papal church had sunk into a ruinous condition. In the mid-15th century, under Pope Nicholas V, plans were finally made to extend old St. Peter's. The decision to rebuild, however, was not made until 50 years later under the highly cultured Pope Julius II, the first pope to employ Michelangelo.

When Michelangelo began work on the construction site in 1546, the project had already been underway for 40 years, and he was the seventh architect to work on it. The original plan by Donato Bramante (ca. 1444–1514) was for a centralized structure arranged symmetrically around the dome, but this had been reworked and changed several times. Michelangelo returned to Bramante's plan, which he praised as "simple, clear, and light."

Opposite:
**Study for the Dome of St. Peter's** (detail)
Charcoal and sepia
25.5 x 25.7 cm
Lille, Musée des Beaux-Arts

This drawing documents Michelangelo's search for an appropriate form for the dome of St. Peter's.

Etienne Dupérac
**External View of Michelangelo's Model for St. Peter's**,
ca. 1568, Copperplate engraving
Paris, Bibliothèque Nationale

Michelangelo's concept of St. Peter's can be fully understood only by examining this engraving. It is thought that Dupérac worked from a wooden model made by Michelangelo, now lost. Michelangelo's design was in fact largely realized, though the nave was lengthened and the entire structure given a broad façade.

As the pope had given him executive powers of decision-making, he was able to use his own judgement to alter the plans, or even to tear down parts of the building if he thought it necessary. In fact he had no compunction in demolishing the work of his predecessor, Antonio da Sangallo the Younger, which he dismissed as too gloomy, too impractical, too expensive, and too large.

Michelangelo concentrated in particular on the dome, which was to stand directly over the grave of St. Peter. His designs indicate an intensive study of the dome of Florence Cathedral, built by the famous Florentine architect Brunelleschi. When Michelangelo died, the building of St. Peter's dome had only proceeded as far as the drum. The dome itself was not completed until 1588–1590, by the architects Giacomo della Porta and Domenico Fontana, albeit in a more pointed form than Michelangelo had intended.

**St. Peter's, Dome**
1546–1590
Rome, St Peter's in the Vatican

The enormous dome of St. Peter's, which was designed to be seen from a great distance, was of the utmost importance to Michelangelo. The dome of Florence Cathedral by Filippo Brunelleschi may have been the inspiration for his plans. Michelangelo modestly said of the Florence dome he so much admired, that he would build a sister for it in Rome that would be bigger – but not more beautiful. Michelangelo's drawing on the left shows Brunelleschi's influence in the round windows of the drum; these were later changed.

# The Last Sculptures

At the end of his life Michelangelo once again turned to sculpture; in contrast to painting and architecture, he had always considered sculpture his true calling. A French traveler reported that the aging sculptor still had astonishing physical strength: "He was well past his sixtieth year and, although not very strong, he hammered as many chips from a block of marble in a quarter of an hour as three young stonemasons could have if they had worked three or four times as long. This has to be seen with one's own eyes to be believed. He attacked the work with so much fire and passion that I thought the piece would surely shatter. With a single blow he knocked off shards with the thickness of three or fingers, but so precisely that, were only a little more marble to be broken off, he would have risked ruining the whole."

The two sculptural groups he began in the 1550s were small commissions that Michelangelo worked on solely out of personal interest. Today these pieces are on display in Florence and Milan. Michelangelo is even said to have intended the Pietà that is now in the Florence Cathedral Museum (left) for his own tomb. Certainly both sculptures reflect not only his profound piety, but also his increasing preoccupation with death.

On February 18, 1564, a few weeks before his 89th birthday, Michelangelo died in Rome. His closest friends were at his bedside.

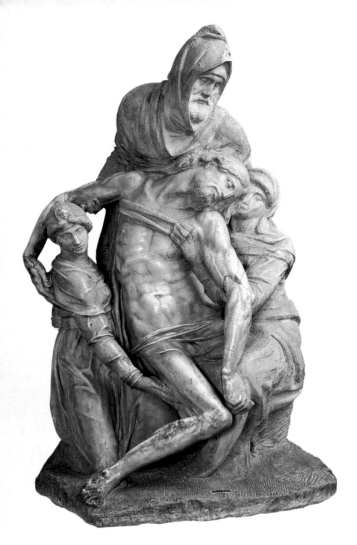

**Pietà**
Begun before 1550
Marble
Height 226 cm
Florence, Museo dell'Opera del Duomo

The figure of Nicodemus at the rear, who had helped take Christ down from the cross and lay Him in his own grave, is said to have been given Michelangelo's own features. Michelangelo, frustrated by imperfections in the marble, broke off Christ's left leg and arm and gave the whole sculpture to a friend. One of Michelangelo's pupils restored the Pietà, and completed the figure of Mary Magdalene on the left.

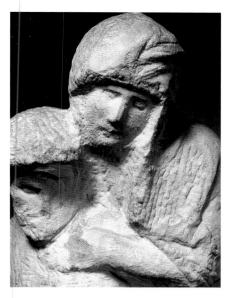

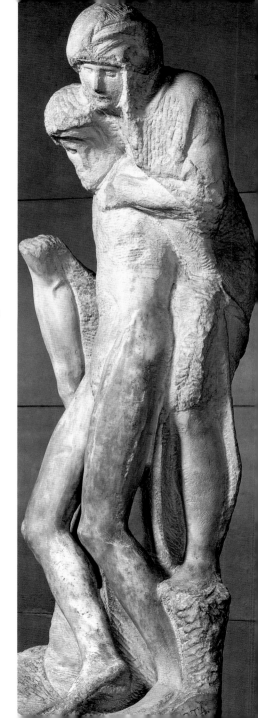

Left and right:
**Rondanini Pietà**
1552–1564
Marble
Height 195 cm
Milan, Museo del
Castello Sforzesco

Michelangelo is said to have worked on this lamentation scene just a few days before his death. His portrayal of mother and son here is completely different from his portrayal of them in his earlier work on the same theme, the *Pietà* in St. Peter's (page 23).

Here, rather than cradling her dead son in her lap, the Virgin is standing behind him. In order to support his larger body, she is given an elevated position on a stone. Just how radically Michelangelo reworked the piece in order to give it its final form is evident from Christ's disembodied right arm, which seems to be left over from an earlier version.

The unfinished work is named after the palace in whose courtyard it once stood.

According to Vasari, Michelangelo's last words were to commend his soul to God, his body to the earth, and his property to his next of kin. His last wish was to be buried in his home town of Florence. The Romans were apparently reluctant to part with their "divine Michelangelo," and it was only by means of subterfuge that his nephews were able to smuggle his body out through the city gates.

Eugène Delacroix
**Barque of Dante
(Dante and Virgil in
Hell)**
1822
Oil on canvas
189 x 241.5 cm
Paris, Louvre

Delacroix's picture was
inspired by various
works by Michelangelo.
Some of the naked
muscular figures have
poses similar to those
in *The Last Judgment*.
The influence of
Michelangelo's
sculpture is also
apparent in Delacroix's
painting. The figure
floating in the water in
the left foreground, for
example, is reminiscent
of Michelangelo's
*Dying Slave*, in the
Louvre in Paris (page
58), while the figure
with the blue cape can
be compared to *Day*
from the Medici
Chapel.

**Day** (detail from
the Tomb of Giuliano
de' Medici)
1526–1531
Marble
Florence, San Lorenzo,
Sagrestia Nuova

# Michelangelo in the 19th Century

Despite the fact that he never established a school of art as such, Michelangelo's works have constantly been the object of study and imitation down through the centuries. In the 19th century, interest in Michelangelo the painter as well as Michelangelo the sculptor was again reawakened.

In his *History of Italian Painting* (1817), the French writer Stendhal wrote admiringly of the grandeur of Michelangelo's style.

Romantic artists of the first half of the 19th century, like the painter Eugène Delacroix (1798–1863), who produced expressive works laden with pathos, studied the Italian artist closely. Delacroix's first masterpiece, the famous *Barque of Dante* (above), which depicts a scene from *The Divine Comedy* by Dante Alighieri, was clearly influenced by works by Michelangelo.

In the second half of the 19th century, Auguste Rodin (1840–1917) discovered in Michelangelo his great artistic exemplar. Rodin, many of whose sculptures show the influence of Michelangelo's work, confessed that his discovery of Michelangelo's art had had a profound effect on him in his youth: "I liked to read and spent a lot of time in the public library near the Pantheon. One day I saw a book with engravings of works by

Michelangelo. They were a revelation for me. […] I had found my calling!"

Michelangelo not only enriched art through his extraordinary talent and genius, but he also led it on to new paths. Equally gifted in all the fine arts – in painting, sculpture, and architecture – he created work that set the highest standards for centuries to come.

Auguste Rodin
**Gates of Hell**
1880–1917
Bronze
550 x 370 cm
Paris, Musée Auguste Rodin

Rodin never completed his *Gates of Hell,* which he began in 1880. Commissioned for the Museum of Applied Arts in Paris, it was a project that occupied him for 30 years. Like Delacroix's *Barque of Dante* (opposite), the work of the Florentine poet Dante Alighieri provided the inspiration for Rodin. Dante's epic poem had preoccupied Rodin from the time of his journey to Italy in 1875–1876, on which occasion he also had the opportunity of studying Michelangelo's work at first hand.

**Damned Man**
(detail from *The Last Judgment*)
1537–1541
Fresco
Rome, Vatican, Sistine Chapel

Rodin's famous *Thinker* – seated at the top of the door in his *Gates of Hell* (left) – may well have been inspired by this portrayal of a damned man from *The Last Judgment* in the Sistine Chapel.

The Later Works (1542–1564) **91**

# Glossary

**All' antica** (Italian "from the antique") Of an art work, in the style of classical Greek or Roman art.

**Atlas** In architecture, a load-bearing column carved in the form of a man. (In Greek mythology, Atlas was a giant who had to support the sky on his shoulders.)

**Attribute** A symbolic object used in art to identify a specific person, usually a saint.

**Aureole** In a painting, a circle of light shown surrounding a holy person; a halo.

**Bozzetto** plural **bozzetti** (Italian) A small-scale preparatory model of a sculpture.

**Cartoon** A full-scale preparatory drawing for a painting, tapestry, or fresco.

**Centralized perspective** See perspective.

**Charon** See Styx.

**Classical** Relating to the culture of ancient Greece and Rome (classical antiquity). The classical world played a profoundly important role in the Italian Renaissance, with scholars, writers, and artists seeing their own period as the rebirth (the "renaissance") of classical values after the "long darkness" of the Middle Ages.

**Console** In classical architecture, an ornamental bracket carved (in profile) in an S-shape.

**Contrapposto** A pose in which the upper part of the body turns in a direction opposite to that of the lower half, the weight of the body falling on one leg. First used by sculptors in ancient Greece, it was revived by Renaissance artists and became a common feature of Mannerist sculpture.

**Cornice** A molded horizontal ledge along the top of a building or wall.

**Council of Trent** A 16th-century Roman Catholic council convened to reform the Church, and in particular to develop measures to combat the spread of Protestantism. It set about clarifying doctrine and placed a new emphasis on teaching, missionary work, and the use of the arts in promoting the Church's message.

**Counter Reformation** A 16th- and 17th-century reform movement in the Roman Catholic Church. Prompted initially by internal criticism, it was given greater momentum by the emergence of Protestantism. The Counter Reformation led to a new emphasis on teaching, missionary work, and the suppression of heresy.

**Drum** In architecture, a cylindrical wall, sometimes pierced by windows, supporting a dome.

**Engraving** A printing technique in which a design is cut into a metal plate (usually copper) by means of a sharp instrument. When ink is wiped firmly across the plate, it fills the fine incised lines and is then transferred to paper when the plate and the paper sheet are pressed together.

**Foreshorten** In a drawing or painting, to represent an object reduced in length in order to create sense of depth or distance. Foreshortening is an aspect of linear perspective.

**Great Schism** A split in the Roman Catholic Church 1378–1417 when there were two lines of papal succession, one in Rome and one in Avignon in France.

**Humanism** An intellectual movement that began in Italy in the 14th century. Based on the rediscovery of the classical world, it took man, rather than God, as the measure of all things. A new attitude to the world rather than a set of specific ideas, humanism was reflected in literature, the arts, scholarship, philosophy, and science.

**Laocoön** In Greek mythology, a priest who, having offended the gods, was punished by being crushed to death by two giant snakes.

**Linear perspective** See Perspective.

**95 Theses** A list of challenges to Church practices drawn up by the monk Martin Luther (1483–1546), who nailed them to a church door in Wittenburg, Germany, in 1517. Challenging wide-spread corruption in the Church, the 95 Theses provoked intense debate.

**Pazzi Conspiracy** A conspiracy in Florence in 1478 to topple the powerful Medici family; Giuliano de' Medici was stabbed to death at church, his brother Lorenzo escaped. The conspiracy was soon suppressed and its leaders executed.

**Pediment** In classical architecture, the triangular end of a low-pitched roof; especially in Renaissance architecture, a decorative architectural element over a door or window, usually triangular. A **segmental pediment** has a round top.

**Pendentive** A curving and concave triangular section of roof vaulting.

**Perspective** A method of representing three-dimensional space on a flat surface, i.e. of giving a picture a sense of depth. Since the Renaissance the most important form of perspective has been **linear perspective**, in which the real or suggested lines of depicted objects converge on a **vanishing point** on the horizon. Linear perspective was first formulated by the architect Filippo Brunelleschi (1377–1446) and first used

systematically by the painter Masaccio (1401–ca.1428).

**Pietra serena** (Italian) A clear, gray limestone that is a distinctive feature of architecture of Renaissance Florence.

**Reformation** A 16th-century movement that began as a search for reform within Roman Catholic Church and led eventually to the establishment of Protestantism. This split in Western Christendom had profound political and cultural consequences, with the whole of Europe dividing into opposed and often hostile camps. The leading figure of the early Reformation was Martin Luther (1483–1546).

**Relief** A sculptural work in which all or part projects from the flat surface. There are three basic forms: *low relief*, in which figures project less than half their depth from the background; *medium relief*, in which figures are seen half round; and *high relief*, in which figures are almost detached from their background.

**Rilievo schiacciato** (Italian "flattened relief") A form of sculptural relief developed by the Florentine sculptor Donatello (1386–1466). A very low relief, almost two-dimensional, that allows the sculptor to create effects (particularly spatial effects) similar to those seen in painting.

**Sarcophagus** A coffin or tomb, made of stone, wood or terracotta, and sometimes carved with inscriptions and reliefs.

**Sibyls** In classical antiquity, women who could predict the future. In Christian legend, sibyls were thought to have foretold the Birth, Passion, and Resurrection of Christ, and so were seen as the classical counterparts of the biblical prophets.

**Study** A preparatory drawing for a painting or sculpture. Studies can be executed in a wide variety of formats, their degree of completeness ranging from a fleeting sketch to a detailed drawing.

**Styx** In Greek mythology, the river the dead must cross in order to reach the Underworld, which in the Renaissance was seen as the pagan equivalent of Hell. **Charon** was the ferryman who took souls across the Styx.

**Tempera** A painting technique in which the pigments are mixed with an emulsion of water and egg yolks. Tempera was widely used in Italian art in the 14th and 15th centuries, both for panel painting and fresco, and was then replaced by oil paint.

**Tondo** plural **tondi** (Italian "round") A circular painting or relief sculpture. The tondo derives from classical medallions and was used in the Renaissance as a compositional device for creating what was thought to be an ideal visual harmony. It was particularly popular in Florence and was often used for depictions of the Madonna and Child.

**Vanishing point** See Perspective.

# Index

**Chronology Illustrations**
Page 7, top left
Sebastiano del Piombo
*Portrait of Christopher Co-
lumbus*
1519, oil on canvas,
106.7 x 88, 3 cm
New York, Metropolitan Mu-
seum of Art

Page 7, top right
*Three Standing Men*
ca. 1492, pen on paper
29.4 x 20.1 cm
Vienna, Graphische Samm-
lung Albertina

Page 17, top left
Anonymous
*Execution of Savonarola on
the Piazza della Signoria,*
(detail)
Tempera on wood
Florence, Museo di San Mar-
co

Page 17, top right
*Profile of a Youth*
ca. 1500, pen on paper
32.5 x 26.1 cm
Paris, Louvre, Cabinet des
Dessins

Page 25, top left
Leonardo da Vinci
*Mona Lisa*, 1503
Oil on canvas, 77 x 53 cm
Paris, Louvre

Page 25, top right
*Portrait of a Youth*, 1501
Pen on paper, 25.4 x 16.8 cm
Oxford, Ashmolean Museum

Page 39, top left
Santi di Tito
*Niccolò Machiavelli*
ca. 1590, oil on canvas
Florence, Palazzo Vecchio

Page 39, top right
*Zachariah*, Study for a figure
in the Sistine Chapel
1509–1510, Charcoal on pa-
per, 43.5 x 28 cm
Florence, Uffizi

Page 53, top left
Workshop of Lucas Cranach
the Elder
*Portrait of Martin Luther*
1529, Oil on wood,
34.3 x 24.4 cm
Florence, Uffizi

Page 53, top right
*Half-length Portrait of a
Screaming Man (so-called
Damned Man)*, ca. 1525
Black ink on paper
35.7 x 25.1 cm
Florence, Uffizi

Page 61, top left
*Hernan Cortés Being Received
    in Mexico*
Illustration from: Diego Du-
ran, *Historia de las Indias*

Page 61, top right
*Madonna and Child*
ca. 1523, charcoal with red
chalk and ink on card
54 x 39.7 cm
Florence, Casa Buonarroti

Page 71, top left
Hans Holbein
*Henry VIII*, 1537
Oil on wood, 89 x 75 cm
Lugano, Sammlung
Thyssen-Bornemisza

Page 71, top right
*Brutus*, ca. 1538
Marble, height 74 cm
Florence, Museo Nazionale
del Bargello

Page 79, top left
Anonymous
*The Council of Trent*
Copy from the
contemporary original, 1769

Page 79, top right
Daniele da Volterra
*Portrait Bust of Michelangelo
Buonarroti*, 1565
Bronze, Florence, Galleria
dell'Accademia

## Acknowledgments

The publisher would like to thank all contributing museums, archives and photographers for granting the right to reproduce images, and for their generous support in the production of this book.

© Archiv für Kunst und Geschichte, Berlin: 7 t l, 9 b, 11 b, 14 b, 17 t l (Photos: Erich Lessing), 22 l, 25 t l, 33 b, 39 t l, 53 t l, 61 t l, 62 b (Photos: Orsi Battaglini), 65 t l/b, 68 r (Photos: Erich Lessing), 71 t l, 79 t l, 80 t/b, 91 l.

© Archivio Fotografico Electa, Milan: 86

© Ashmolean Museum, Oxford: 25 t r/b

© Raffaelo Bencini, Florence: 9 t, 46 b

© Bildarchiv Preussischer Kulturbesitz, Berlin 1999: 13 right (Jörg P. Anders, Berlin 1979), 26 r (Jörg P. Anders)

© The Bridgeman Art Library, London: 23, 27, 35 t, 46 t, 53 t r, 61 t r, 76, 77 b

© The Trustees of the British Museum, London: 30 r t, 61 b, 72 r, 77 t, 78

© Casa Buonarroti, Florence: 2, 28 t, 39 b (Archivio Buonarroti), 53 b, 62 t, 64 b, 79 t r/b

© Fratelli Alinari, Florence 1999: 8 b, 15 l, 18 t, 34 b, 37 r/l, 82 t, 88

© Graphische Sammlung Albertina, Vienna: 7 t r, 34 t

© KÖNEMANN* in der Tandem Verlag GmbH, Königswinter: 83 r (Photo: Achim Bednorz)

© Board of Trustees of the National Gallery, London: 64 t

© Marco Rabatti/Serge Dominige, Florence: 69 l

© RMN, Paris: 17 t r, 58 r, 74 l (Photo: R.G. Ojeda), 84 (Photo: J.G. Berizzi), 87 l, 90 t

© Photo Scala, Florence: 10 t/b, 11 t, 12, 13 l, 14 t, 15 r, 16, 17 b, 18 b, 19, 21 r/l, 22 r, 24, 26 l, 28 b, 29, 30 l, 31, 32 r/l, 33 t, 35 b, 36, 39 t r, 41, 50 r, 52, 54 r /l, 55 l, 56 t/b, 57, 58 l, 59, 60, 63t/b, 65 t r, 66 t/b, 67 t r, t l, b, 68 l, 69 r, 71 t r, 72 l, 74 r, 75 r, 81, 82 b, 87 r, 89 r/l, 90 b

© Giovanni Simeone, San Vendemiano: 85 b

© Staatliche Graphische Sammlung, Munich: 6

© Vatican Museums: 38, 40, 42/43, 44, 45 t/b, 47 t/b, 48, 49 t/b, 50 l, 51, 70, 71 b, 73, 75 l, 91 r.

The editor has made every effort to secure all relevant copyrights and other commercial rights for this book; he may be contacted at any time to answer queries on these matters.

## Key

| | |
|---|---|
| r = right | l = left |
| t = top | b = bottom |
| c = center | |

© 2005 KÖNEMANN*, an imprint of Tandem Verlag GmbH, Königswinter

Editor: Peter Delius
Series concept: Ludwig Könemann
Art director: Peter Feierabend
Coverdesign: Claudio Martinez
Editing and layout: Barbara Delius
Picture research: Jens Tewes

Original title: Michelangelo Buonarroti. Leben und Werk
ISBN 3-8331-1071-6 (original German edition)

© 2005 for the English edition: KÖNEMANN*, an imprint of Tandem Verlag GmbH, Königswinter

Translation from German: Peter Barton in association with Goodfellow & Egan
Editing: Chris Murray in association with Goodfellow & Egan
Typesetting: Goodfellow & Egan, Cambridge
Project management: Jackie Dobbyne for Goodfellow & Egan Publishing Management, Cambridge, UK
Project coordination: Nadja Bremse

*KÖNEMANN is a registered trademark of Tandem Verlag GmbH

Printed in Italy

ISBN 3-8331-1465-7

10 9 8 7 6 5 4 3 2
X IX VIII VII VI V IV III II I

Front cover
**Christ and Mary**
(detail from *The Last Judgment*), 1536–1541
Fresco
Rome, Vatican,
Sistine Chapel

Page 2
Marcello Venusti
**Portrait of Michelangelo Buonarroti**, ca. 1535
Florence, Casa Buonarroti

Back cover
**David** (detail) 1501–1504
Marble
Height 410 cm
Florence, Galleria dell'Accademia